Van Gogh

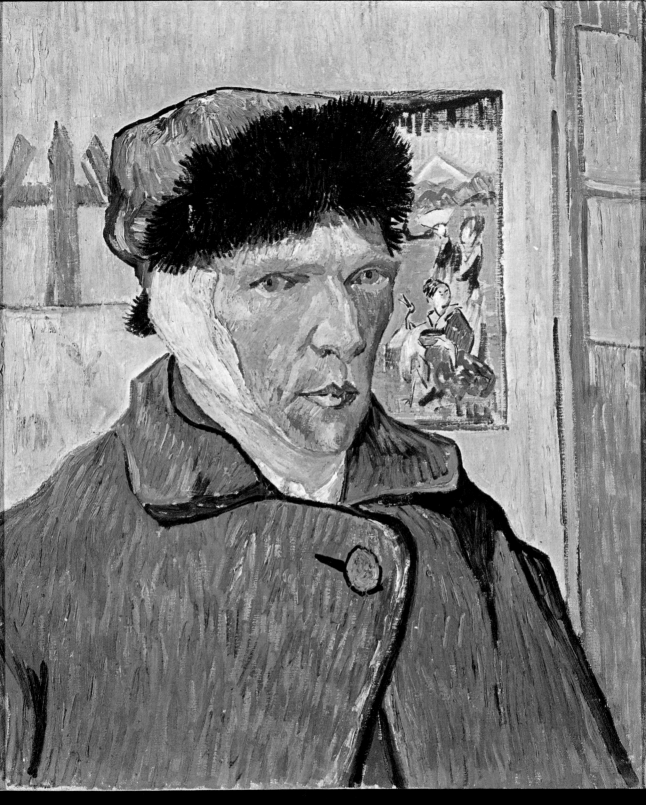

Self-Portrait with a Cut Ear. Arles, January 1889.
Canvas, 23⁵/₈ × 19¹/₄ in. London, Courtauld Institute Galleries.

Van Gogh

Jacques Lassaigne

CHARTWELL
BOOKS, INC.

CONTENTS

SERIES DIRECTED BY DANIEL WILDENSTEIN
AND
REALIZED WITH THE COLLABORATION OF THE WILDENSTEIN FOUNDATION, PARIS

Photo credits: Wildenstein Archives, New York; Gruppo Editoriale Fabbri, Milan; Lalance, Paris; Clichés des Musées Nationaux, Paris; TELARCI, Paris; Howald, Bern; AGRACI, Paris; Giraudon, Paris; Van Rhyn-Viollet, Paris; Roger-Viollet, Paris; Lipnitzky-Viollet, Paris; Josse, Paris; Hinz, Basel; Stickelmann, Bremen; John Webb, London; Carlo Bevilacqua, Milan.

Published in the United States, 1982
Chartwell Books, Inc.
A Division of Book Sales, Inc.
110 Enterprise Avenue
Secaucus, New Jersey 07094

ISBN 0-89009-516-7

Printed in Italy by Gruppo Editoriale Fabbri S.p.A., Milan, Italy

ABOVE ALL –
A PAINTER

by ÉMILE BERNARD

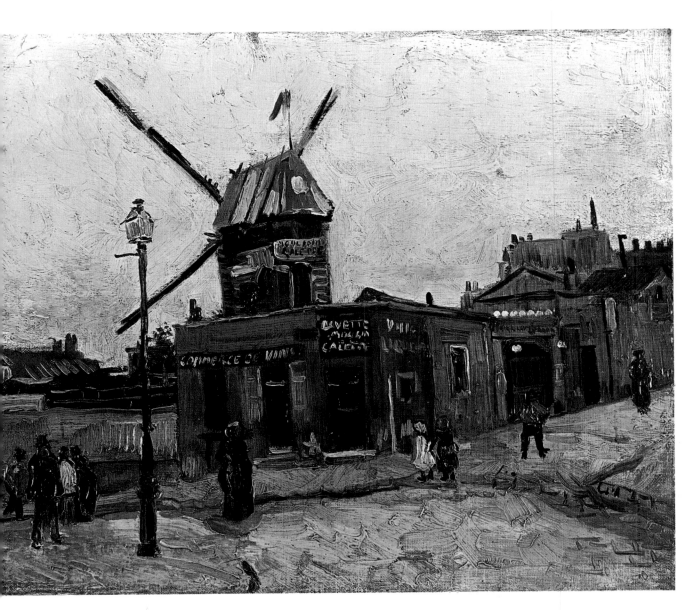

Le Moulin
de la Galette.
Paris, 1886.
Canvas,
$15^1/_8 \times 18^1/_8$ in.
Otterlo,
Kröller-Müller
Stichting.

A painter he is, a painter he remains: whether, as a young man, he interprets Holland in brown or, a little older, he paints Montmartre and its gardens as a divisionist, and finally the South of France and Auvers-sur-Oise with a furious impasto. Whether he draws or not, whether he loses himself in patches of color or in distortions, he always remains a painter. And it is this, to-gether with the rare harmonies he some-times finds in a new combination of certain tones, which gains him attention and brings him to the fore among men of temperament. This « little gift » he has, a gift he gradually magnifies, and sometimes perhaps to the detriment of all the rest, till it dominates the related investigations he undertook in vain. He is not always a stylist; often, indeed, he

is far from it. As a draftsman, he labors to put the fingers on a hand, yet without managing to rid himself of that pincerlike look to which he naturally tended. As a colorist, he does not always succeed in balancing color schemes; sometimes they grate to the point of shrillness, sometimes they are so subdued as to be insipid. But always there are those thickly textured pigments—solid, durable, manipulated in a frenzy of expression and ready for the splendid patina the future will lend them. Yet Vincent did everything to perfect his drawing, in order to draw according to his vision and the reality of things! I can still see him at Cormon's, in the afternoon, when with the others gone the empty studio became for him a kind of cell. Sitting before a plaster cast of some Classical statuary, he copied its beautiful forms with angelic patience. He was intent on mastering those contours, those masses, those raised surfaces. He would correct his work, resume with passion, rub out again, and finally wear a hole in the paper with the pressure of his eraser. He did not realize, in the face of that Mediterranean wonder, that everything about him as a Dutchman was opposed to the very conquest he strove for. Through the Impressionists, with their free imagination and relaxed lyricism, he would find a better way for himself, and sooner, than through this calm perfection revealed to serener men in civilizations closer to nature and to reason.

How soon Vincent came to understand that! So he left Cormon's atelier and let himself go. He no longer dreamed of drawing like the ancients, nor of painting—as he had under his temporary master—female nudes surrounded by imaginary carpets, like odalisques in a seraglio of inebriated fantasy. But if he did not become « antique, » at least he believed he was becoming French. In following the Impressionists and taking lessons in their school of glowing color, « we are working toward the French Renaissance, » as he wrote to his brother Theo (who, at his urging, exhibited Monet at the Boussod-Valadon Gallery), « and I feel more French than ever at this task; here we are in a motherland. » And it was true, Vincent was becoming French: he painted Montmartre, its stunted little gardens, the Moulin de la Galette, its taverns; he even took excursions as far as Asnières. He visited the island of La Grande Jatte, already becoming known for Seurat's schematic researches there. Setting out with a large canvas slung on his back, he would then divide it up into compartments, according to the varied subjects he came across. In the evening he brought it back full, like some small itinerant museum in which all the emotions of his day were caught. There were glimpses of the Seine full of boats, and islets with blue seesaws, neat little restaurants with their multicolor blinds amid oleanders, corners of neglected gardens, or houses for sale.

Emile Bernard, Preface to *Lettres de Vincent Van Gogh à Emile Bernard,* Ambroise Vollard, Paris, 1911, pp. 10-12.

UNDER THE SIGN OF FIRE

by RENÉ HUYGHE

Van Gogh is Nordic, Dutch; he is no son of those Latin lands where the mind embodies the principle of harmony and equilibrium, an organizing and regulating agent. The Nordic man may readily be positive in outlook, but as soon as the leaven of thought begins working in his mind, it casts a halo of anxiety and confusion around reality. It cuts him loose from what is stable and concrete, and he drifts off into the imaginary. He breaks out of his circle of security and begins his adventure into the unknown: he becomes a « possessed » soul.

A Protestant, the son and grandson of ministers, Van Gogh was heir to a religion whose rectitude could not tolerate the hesitations of a sensitive spirit—that which freed him, yet also consumed and ravaged his innermost soul. It was through the Protestant Church that he first, before becoming a painter, sought to quench his thirst for the absolute. Like some evangelist of another era from whom his Church, disturbed by his excessive zeal, withdrew his mission, Van Gogh set to work in the dismal Borinage district, so crowded with downtrodden miners. More wretched than was the poorest of his flock, this St. Francis among the miners' hovels shocked even his own parishioners. « A man may have a great fire in his soul, yet no one comes to warm himself at it, and the passers-by see only a wisp of smoke coming out of the chimney and so go on their way »: thus he professed in himself that which « goes on

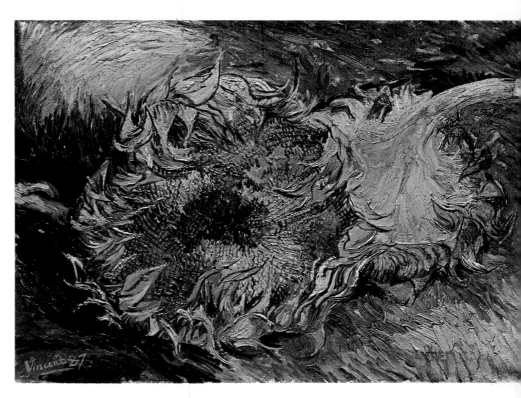

Sunflowers. Paris, 1887. Canvas, 17 × 24 in. New York, The Metropolitan Museum of Art, Rogers Fund, 1949.

living and goes on seeking always and always. »

Finally, Van Gogh was an uprooted soul who, like El Greco, another impassioned artist, skirted the edge of madness. Just as El Greco had left Crete to arrive eventually in Toledo, Vincent left his native Holland to end up in Provence. There Van Gogh found a land that fulfilled the radiant dream toward which he had groped in his native gloom—a land, however, not at all natural for this offspring of foreign soil. Both Van Gogh and El Greco were torn between their hereditary, physical nature and the imaginative being they

carried within them, to which the accidents of life offered an unexpected, abnormal sphere of development. They strained themselves to the breaking point. Their constitution and sensibility were not made for such strong sustenance, which they nevertheless longed for and intoxicated themselves with to the extremes of madness and death. It was different for Cézanne, who had been born in Provence. When he returned and dug in that earth anew, he came closer to his own roots, he found himself; in the burning intensity of that sun, he attained harmony, whereas Van Gogh was consumed by its fierce glare. Van Gogh chose the fire of this blazing sun and its overwhelming light in order to transform himself into a fiery spirit—a flame that burnt itself out in only three years. And most decidedly, he took his stand under the emblem of Fire. If we pass from the dark, rugged and rough-hewn masses of his early Dutch period to the burning bush of lines and colors dancing and swirling in his mature works, those of Arles and Saint-Rémy, it is almost as if we saw some crude block of coal, very slowly formed in substrata of the North, suddenly ignite under the scorching sun of Provence and abruptly release all its stored energy in a dazzling blaze. Inspiration, Baroque or Romantic, arises in the regions of the North where, amid the gloom and cold, fire has held the age-old promise of life; or else it arises in those lands baked by the sun's rays, Spain and Provence, where the Mediterranean equilibrium seems shattered in favor of this celestial fire. It does not flower in temperate lands, or does so with difficulty. In the arts that prefer intensity to harmony—as is the case for Baroque and Romantic art as well as with Van Gogh—form itself presumes to infringe upon the inherent discipline of technique or of nature, to imitate the undulations of the flame: thus it winds, breaks off, escapes, defying the straight lines and calm control of geometry. Is not the baroque phase of the Gothic style called « Flamboyant »?

The signs of fire appear in his color, swept in with a heaving, molten touch, in his reds, blues, and yellows, especially the yellows: « A sun, » he said, « a light that for want of a better word I can only call yellow, pale sulfur yellow, pale lemon gold. How beautiful yellow is! » The sunflower, which above all flowers he loved best, eagerly seeks to turn toward him its saffron disk, radiating with bright petals—the sun from which the sound instinct of the people has given it its name. And in Vincent's last works the cypresses themselves seem to shoot up in sinuous spurts, the fiery wisps of their branches darting toward whirling suns which seem to be creating the very sky with their waves of fire.

René Huyghe, Preface to catalogue of the Van Gogh Exhibition, Musée de l'Orangerie, Paris, January-March 1947, pp. 6-8.

LIFE AND WORKS

1 - THE EARLY YEARS

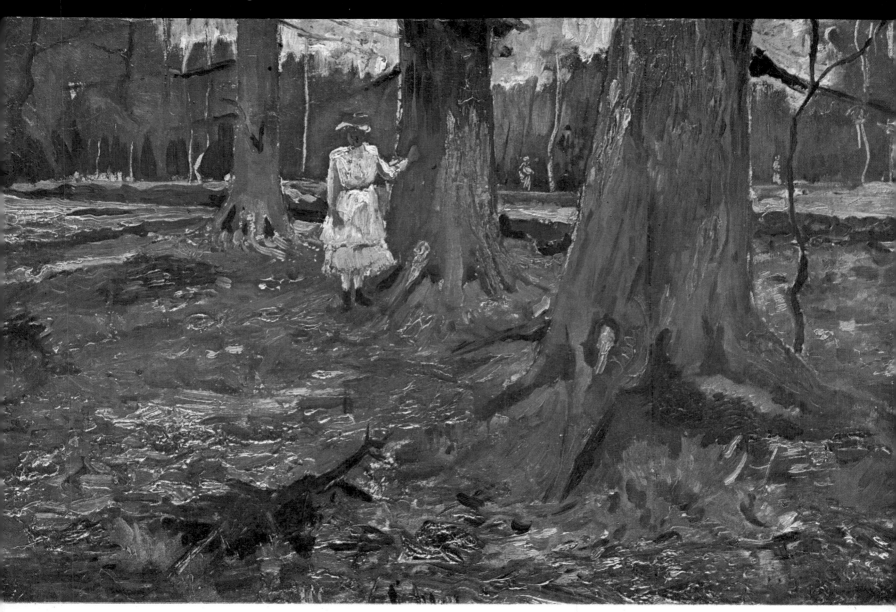

Girl in White in the Woods.
August 1882. Canvas, 15³/₈ × 23¹/₄ in.
Otterlo, Kröller-Müller Stichting.

The son and grandson of Protestant ministers, Vincent van Gogh was born on March 30, 1853, at the parsonage of Zundert, in Dutch Brabant. Having worked all his life in humble country parishes, his father Theodorus van Gogh, a good man dedicated to his calling but with little talent for preaching, had come to that village in 1849. There, in 1851, he married Anna Cornelia Carbentus, daughter of a bookbinder to the court at The Hague. Among her ancestors were a sculptor and several goldsmiths; she had a gift for drawing and a taste for writing. Besides clergymen, the Van Gogh family also had goldsmiths among its ancestors, as well as picture dealers—the occupation for which Vincent was initially intended and which his brother Theo was to follow throughout his life. Theirs was a clannish family, and Vincent's uncles did their best to help him get a start.

The eldest of two brothers and three sisters, Vincent had been named after a previous child who, born a year before him to the day, had not lived and whose grave stood at the entrance to the cemetery of the village church. Thus, every time he went to church he passed a tombstone bearing his own name. Throughout his childhood he was haunted by a sense of occupying the place another had lost; and for his dead namesake, all his life, he felt he had a duty to fulfill—a role and a mission transcending his own personality and urging him on toward the absolute. Vincent was not like other children. He was solitary, dreamy, and uncommunicative; he would not allow his little brothers and sisters to accompany him on his walks, except occasionally Theo. He felt a strong communion with nature and spent hours dreaming in the open countryside, observing the flowers and insects, trying to grasp the

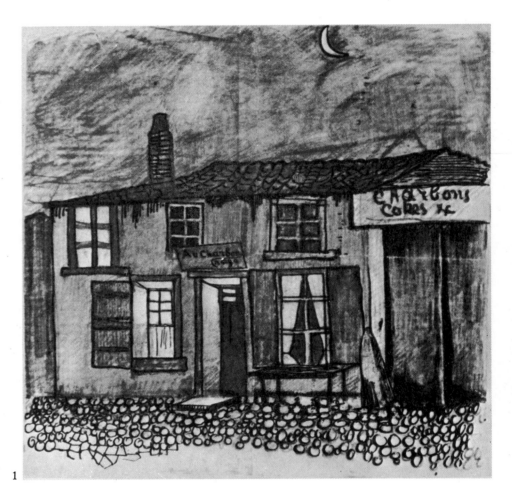

1

mystery of life. Whether brooding in solitude or giving way to sudden fits of temper, he was a source of anxiety to his parents. Already his brothers and sisters were influenced by and were in awe of him.

After some initial study at the village school in Zundert, he was sent to boarding schools in neighboring Zevenbergen and Tilburg. This first separation intensified his sense of family solidarity. When he came home on vacation Vincent was glad to see Theo again, and a close relationship sprang up between the two

brothers as they went on long rambles through the countryside; ever after, both would cherish memories of these happy summer days spent together. Vincent's drawings were to be strongly marked—even more strongly in his periods of crisis—by these boyhood impressions which provided the abiding background of his art and temperament.

His was a large family, and poor Pastor Van Gogh was beset with worries. Quite soon the eldest son had to start earning his own living. On July 30, 1869, he began work in

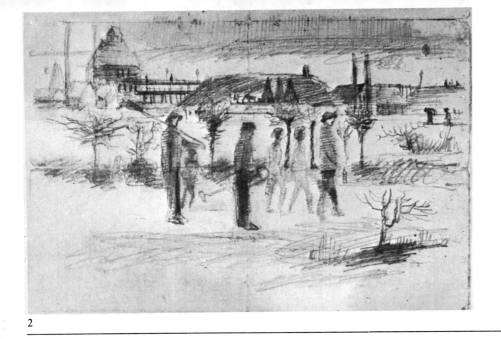

2

The Hague as a salesclerk in an art gallery established by one of his uncles and then sold to the well-known Parisian firm of Goupil, to become its Dutch branch. Vincent's first duties consisted of packing and dispatching books, but he also began to study the stock of prints and reproductions. He discovered the local museum and developed his taste for painting and literature. In 1872, during his August holidays, he spent several weeks with Theo, now fifteen. Each of the brothers had matured appreciably and found they had much in common. When Vincent returned to The Hague they

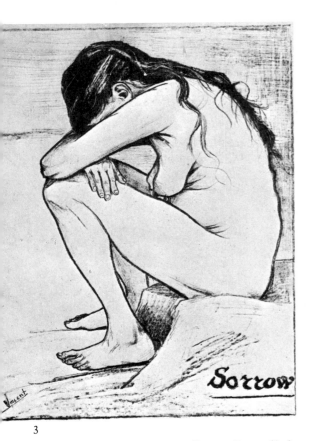

3

began to write to each other, and thus began their lifelong correspondence and profound communion. From the start Vincent tried to interest his younger brother in his ideas and tastes, to share his hopes and plans with him. His letters took the form of long monologues in which, to work out his ideas, he explained himself at length.

On January 1, 1873, having finished his schooling, Theo also went to work for Goupil, first in the Brussels branch of the gallery, then in The Hague. In the spring of the same year Vincent was promoted and was transferred to the important London branch of Goupil; he arrived there in May, after a brief stopover in Paris. At this time it was London, rather than Paris, that made a strong impression on him. Already familiar with it through Dickens's novels, he was fascinated by the city's peculiar atmosphere, with its parks, the ever-present Thames, the strangeness and variety of human types met on his walks along the Thames embankment and in the poorer districts.

In London he had his first unhappy romance. With youthful enthusiasm and candor toward his new world, he fell in love with his landlady's daughter, Ursula Loyer. The girl's mother was the widow of a French pastor. After a few elated strolls with Ursula, he was carried away enough, just before leaving for a vacation in Holland in June 1874, to ask her to marry him. But the girl, already secretly engaged, gave him a lighthearted refusal. He was so plunged into despair that, when he reached the town of Etten, where

his father now had a parish, everyone was struck by his moodiness and low spirits. He took solace in a passion for drawing. When next he returned to London that autumn, one of his sisters went with him. He tried in vain to see Ursula again. This disappointment and suffering turned his mind toward religion. He yearned for self-abnegation—"your ego must die within you"—and he dreamed of doing great things for his fellow men.

In this disillusioned state he was happy, in May 1875, to be transferred to the main Goupil gallery in Paris. There he lived a lonely life but became an assiduous museum-goer. In the Louvre he admired the paintings of Ruisdael; he visited the retrospective exhibition in honor of Corot, who had died earlier that year; he attended a sale of Millet drawings. He decorated his room with prints and reproductions. His earlier artistic preferences were confirmed, but at this time he does not seem to have had any contact with, or any awareness of, the young Impressionist painters who were just beginning to hold their group exhibitions. Gradually he lost interest in his work at the gallery, began to ignore clients, and at Christmastime abruptly left for Holland without advance notice. On his return he handed in his resignation to Boussod and Valadon, who had just taken over the management of Goupil.

For some months his mind had been absorbed by a growing religious fervor. Back in Paris, he would shut himself up in his room to read and discuss the Bible with his only friend, a young Englishman named Harry Gladwell. At home in Etten his family was disturbed by the religious exaltation that had seized him. Vincent was now intent on following his father's example, and to no avail Theo advised him to de-

1 **Au Charbonnage. Pen and pencil drawing in a letter to Theo from Laeken, November 15, 1878.** 5¹/₂ × 5¹/₂ in. Amsterdam, National Museum Vincent van Gogh.

2 **Miners on the Way to Work. Drawing in a letter to Theo from Cuesmes, September 7, 1880.** Amsterdam, National Museum Vincent van Gogh.

3 **Sorrow. The Hague, November 1882. Lithograph, 15¹/₈ × 11¹/₂ in.** Amsterdam, National Museum Vincent van Gogh. (Photo Giraudon)

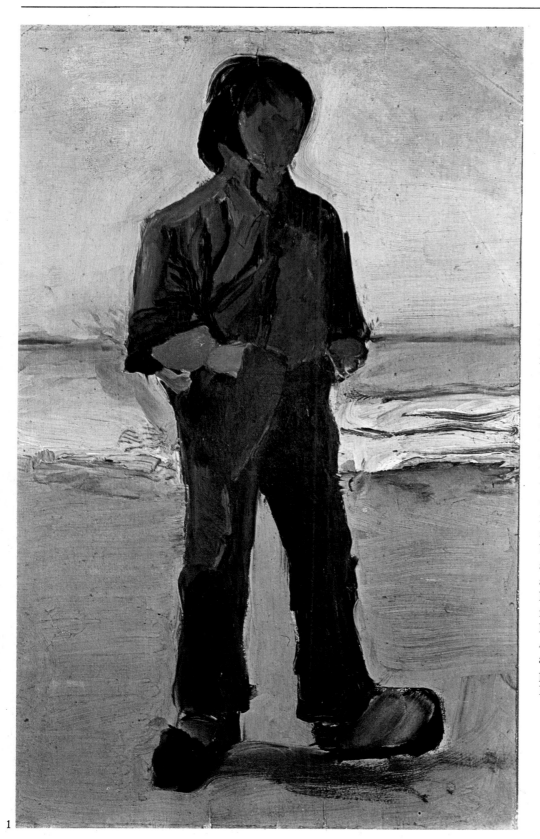

vote himself to painting. By chance he saw a newspaper ad for a post in England as assistant master in French and German; though his knowledge of both languages was skimpy, he impulsively decided to return to the country which had already made such a deep impression on him. Once accepted, he took up his duties in April 1876 in a dismal school at Ramsgate, in Kent, but soon was moved to Isleworth, a poor London suburb. There he assisted a Methodist minister named Jones, as schoolmaster and occasional preacher. Sent out each month to collect the school fees from the children's parents, who lived in the squalid slums of the East End and Whitechapel, Van Gogh was appalled by the misery of the workingmen's families, and his religious convictions were strengthened by this saddening experience. He felt the urgent need of helping the poor, of immersing himself in their lot and serving them selflessly as a minister of god. As assistant to Reverend Jones, even though his English was halting, he tried to preach and convince his destitute congregation of the redeeming merits of their poverty and hardship. One of his sermons, recopied by Theo, was on the theme "Man is a stranger on earth and his life is a storm-tossed voyage." But his exhortations disturbed instead of comforted his listeners. He himself, in his ardor, seemed to lose his balance. At Christmas he gave up his post and returned home to his father's parsonage at Etten.

For a few months early in 1877, he

1

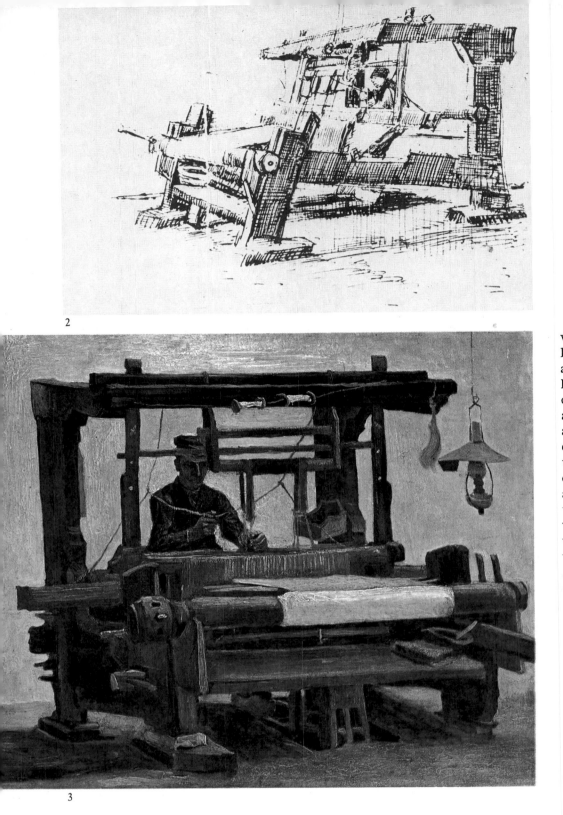

2

3

worked as a clerk in a bookshop in Dordrecht, but his mind was set on his religious vocation. Seeing that he was so determined, his family agreed to help him become a minister like his father and his ancestors. Accordingly, in May he was sent to study at the faculty of Protestant theology in Amsterdam. There his uncle Jan, manager of the shipyards, gave him room and board, and one of his mother's brothers, Pastor Stricker, supervised his studies. Among the subjects required of him were Greek and Latin. A kindly professor, Dr. Mendes da Costa, agreed to tutor him. Vincent tried hard to concentrate on the constant drills, but all his efforts came to nothing: in July 1878, he failed his examination miserably and was not admitted to the seminary. For him there could be no other school but (to use his own words) "the great free university of human affliction." But if he could not be a pastor, if theology and ancient languages were beyond him, he could still preach the gospel of Christ. He succeeded in being admitted as a foreign probationer to an evangelical school for lay preachers at Laeken, near Brussels. After three months' training he came out on November 15, 1878, and solicited a preaching post in the mining district of the Borinage. His French was inadequate and his sermons unpolished, but through the intervention of his father and Reverend Jones, Vincent was allowed to go out on his own as a lay preacher.

He went to the Wasmes region, near Mons, one of the poorest and grimmest parts of the Belgian mining country. Here the miners worked for low wages in unhealthy and precarious conditions. Van Gogh sought to share fully in all their daily sufferings. He gave away everything he had, made his own clothes, and gave up his room to sleep on bare boards in a shed. He sat up all night with sick people abandoned by the doctor, and even cured one. His hands and face smudged with coal soot, he went down into perilous mineshafts and brought the gospel message to the workmen in the pits. His intense devotion and self-denial surprised and even shocked them. They liked him, but could not think of him as a real man of the Church. The inspector from the consistory disapproved of his excessive zeal and spoke in his report of "religious mania." His family was notified, and when Pastor Van Gogh came to fetch his son, he found him lying on a straw-filled sack, weak and thin from his self-imposed privations. He allowed himself to be taken home to Etten, but only after making his parishioners promise to continue their prayer meetings. Again his evangelical efforts had ended in failure.

1 **Fisherman on the Beach. The Hague, August 1883. Canvas mounted on panel, 20^1/$_8$ × 13^1/$_8$ in. Otterlo, Kröller-Müller Stichting.**

2 **Weaver at the Loom. Drawing in a letter to Theo from Nuenen, January 1884. Amsterdam, National Museum Vincent van Gogh.**

3 **Weaver at the Loom. Nuenen, May 1884. Canvas, 27^1/$_2$ × 33^1/$_2$ in. Otterlo, Kröller-Müller Stichting.**

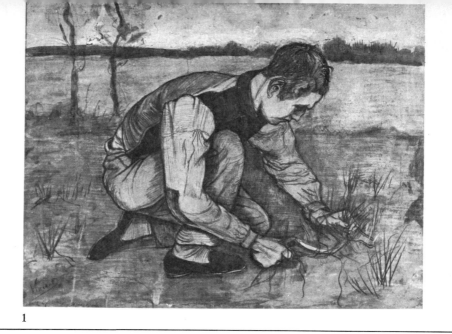

1

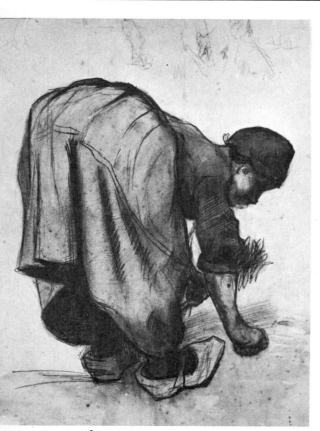

2

But Vincent still believed in and could not wholly renounce his calling. He returned to Brussels and consulted a member of the consistory, Pastor Pietersen, who advised him to try the Borinage once more. Settling this time in the small town of Cuesmes, he devoted his time to drawing, recording the daily round of these humble folk whose life he had shared. One day, in mid-winter, he decided to go to the mining village of Courrières in northern France to seek out the painter Jules Breton, whose work he admired for its social content. He walked all the way, for a whole week, sleeping in barns and sheds. But when he reached Courrières, he was upset by the sight of Breton's fine new studio and left without knocking at his door. This journey opened his eyes to the French sky, so limpid and delicately shaded after the smoke and fog of the Borinage. By now he was convinced there was only one possible outlet for him: to express through art his tragic sense of life.

In the spring of 1880 he returned to Etten. There he received a remittance from Theo, who was working at Goupil in Paris, and after nine months of silence Vincent now wrote him a long letter in French, reviewing his past difficulties and failures and affirming his new sense of purpose. Touched by this confession, Theo wrote back promising him the financial help he needed to study painting. Two months later Vincent wrote to him: "I cannot tell you how happy I am to have taken up drawing again." Of course, he had been drawing since boyhood, and his years with Goupil had familiarized him with the great works in museums and with prints reproducing them. His letters from England were already embellished with drawings, and while in the Borinage he had drawn the miners and the dismal landscape they lived in. But he knew he still had much to learn about design, perspective, and color and hence set about methodically copying two series of pictures by Millet, the *Hours of the Day* and *Labors of the Fields*. He made several drawings (only one survives) after Millet's *Sower*, a figure that haunted him all his life.

He obtained a copy of Bargue's manual of exercises in charcoal sketching and the same author's complete drawing course. But finding that he could not work well in such isolation, and feeling an essential need for closer contact with actual works of art, he went to Brussels. There, on October 15, 1880, he took a room in a small hotel near the station. Theo put him in touch with a young Dutch painter and Academy student, Anton van Rappard, who took Vincent into his studio and taught him the laws of perspective. They found they had similar tastes, the same interest in visual reality rendered directly and accurately, and their friendship gave rise to a protracted and interesting correspondence. Van Gogh settled down to study anatomy, meticulously drawing the different parts of the body and trying to apply these forms to the human figures he had observed in the Borinage. When Van Rappard had to leave Brussels, Vincent felt that this period of fruitful study was over, and he returned to Etten to meet Theo and show him his latest work. He arrived at his father's parsonage on April 12, 1881, this time not with a humiliating sense of failure but buoyed by new hopes.

His parents, now more reassured about his future, gave him a cordial welcome and left him free to work on his own. Moving beyond laborious drills and exercises, he applied his newly acquired technical ability to a delineation of the peasant life around him, something he was familiar with and fond of since childhood. Etten is a small village not far from Zundert, and its fields and woodlands, its thatched cottages, barns, and mills, its carts, plows, and wheelbarrows, its forge, work-

1 **Young Peasant with a Sickle. Etten, October 1881.**
 Black chalk and watercolor, 18½ × 24 in. Otterlo, Kröller-Müller Stichting.
2 **Gleaner. Nuenen, 1885.**
 Pencil, 20⅝ × 17⅛ in. Otterlo, Kröller-Müller Stichting.
3 **Peasant Plowing with Peasant Woman. Nuenen, August 1884.**
 Canvas, 27¾ × 67 in. Wuppertal, Museum Von der Heydt. (Photo Giraudon)

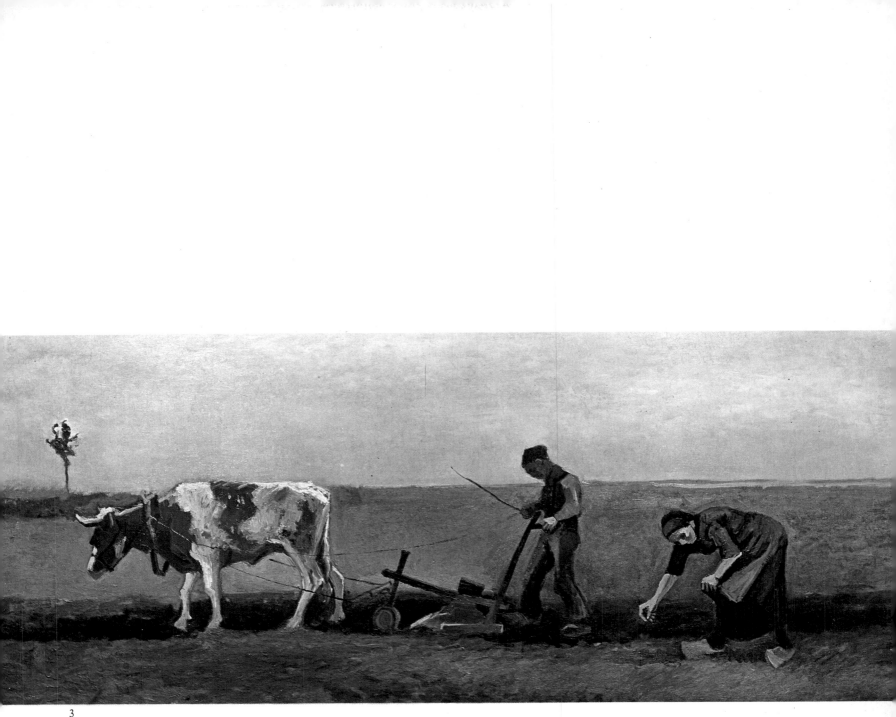

3

shops, and sabot factory held no secrets for Vincent. In his exhilarating new mastery of pen, pencil, charcoal, India ink, and watercolor, he drew up a methodical and perceptive inventory of all he saw. Van Rappard and Theo paid him a visit and encouraged him. He drew his parents and his favorite sister, Wilhelmien. He spent a few days in The Hague and visited his cousin, the painter Mauve, who introduced him to a group of local artists. Mauve showed interest in Van Gogh's work and encouraged him to draw from live models. Acting on his advice, Vincent set to work at Etten on a series of sketches of men and women working in the fields. These drawings were heightened with watercolor, which softened and enhanced their rugged outlines.

But this tranquil and fruitful period of concentrated effort was broken off by another crisis. Van Gogh fell in love with one of his cousins, Kee Vos, the daughter of Pastor Stricker.

A young widow with a four-year-old boy, she was then living with Vincent's parents. But when he asked her to marry him, she gave a crushing reply: "No, never, never!" When he realized he could not change her mind and that she intended to remain faithful to the memory of her husband, he devised a curious way of proving his love. Van Gogh went to her parents' home in Amsterdam, where she had secluded herself to avoid him, and finding there Pastor Stricker and his wife at table he put his hand over the oil lamp and begged them to let him see their daughter for as long as he could bear the heat of the flame. Shocked by his act, they blew out the lamp and showed him to the door.

This fresh failure left "an immense void" in his heart. He returned to Etten for Christmas, but his agitated state led to an absurd quarrel with his father, who ordered him out of the house. He then rejoined Mauve and his circle of artist friends in

The Hague, convinced that painting was his only refuge. His artistic powers were maturing rapidly. From this short stay at Etten in 1881 dates a series of admirable nature studies, drawings that depict ponds dotting the heath and marshes with water lilies. Their dominant horizontal layout under a broad sky shows a remarkable spatial organization and deft use of crosshatching to bring out the prime elements and create nuances in the design, as might be done in printmaking. He had accumulated a print collection of his own, which he studied continually. He soon broke with Mauve, whose art he considered academic, and in his desire to capture the elusive aspect of skies and atmosphere he looked to the landscapes of the Dutch old masters. He tried to render the truth of nature by a minute delineation of its components, in a manner reminiscent of both the precision of early Flemish art and Oriental calligraphy.

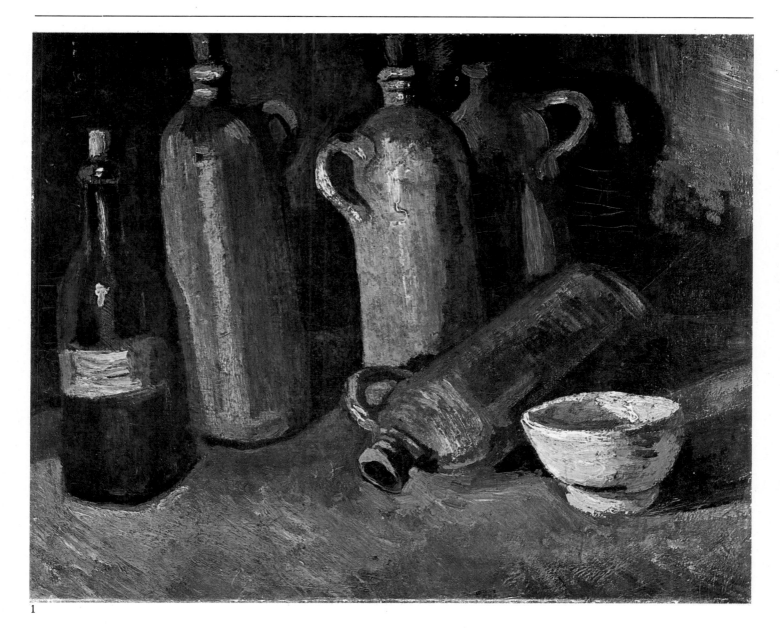

1

His small room in a working-class suburb of The Hague also served as his studio and was fitted out with his prized prints and modest possessions. Here he did a series of views from his window, pencil drawings and watercolors highlighted with white: the bare landscape after a thaw, leafless branches and foraging birds contrasting with the snow. In these the urban architecture, the horizontals of streets and roofs, and the broken quilt of gardens created a more complex perspective pattern. One day in late January 1882, Van Gogh met with a poor outcast in the street, a pregnant prostitute, already the mother of a little girl. Her name was Christine—Sien for short. He took her in and tried to reclaim her. She became his companion and model and, though he had not forgotten his beloved Kee, Vincent lavished on Sien his need for tenderness and compassion.

A well-known drawing, his *Sorrow*, shows her sitting naked, with her head hidden in her arms. Strong, undulating outlines give this expressive image of despair a monumental power that is to recur constantly in Van Gogh's figures. This work, in its absolute sincerity, already enshrines some of the abiding characteristics of his art: his identification with and sympathy for human suffering, his disdain for conventional beauty, his constant quest for unadorned truth.

He managed to live by selling a few watercolors, but he dismissed the suggestion of his Uncle Cornelius of Amsterdam that he do picturesque views of The Hague rather than depict the poverty-ridden back streets where he found his true inspiration. He fell ill and spent several weeks in the hospital. Then Sien gave birth to a boy, and Vincent generously installed her and the two children in new lodgings with an attic he could use as a studio. Theo, whose remittances were practically Vincent's only means of subsistence,

2

paid him a visit and sought to persuade him not to marry Sien, who had taken to drink again and seemed a hopeless case. After a difficult winter, he decided to take Van Rappard's advice and move back to the country, to Drenthe province. Sien refused to accompany him, so he left her behind; the break affected

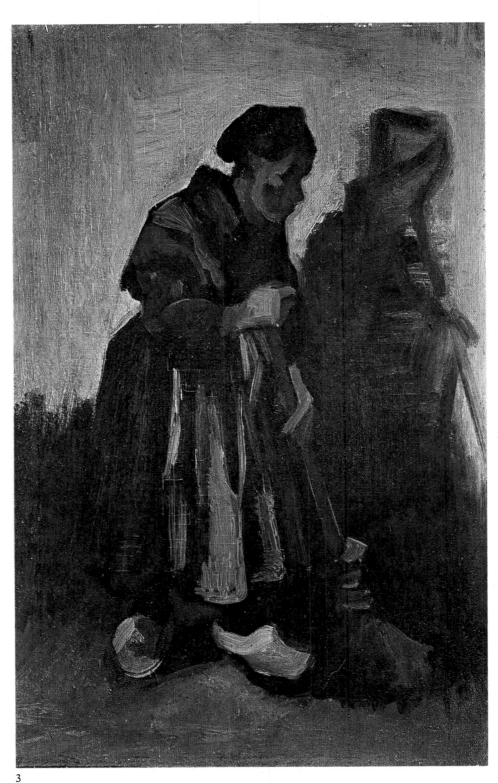

3

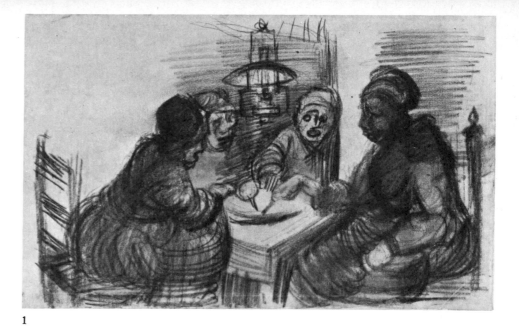

1

him deeply, particularly since he had become so attached to her children. This stay in The Hague was decisive for Van Gogh. The trials and difficulties he had surmounted only served to fortify his determination. He read voraciously (Dickens, Balzac, Hugo, Zola, the Goncourts) and meditated upon and enriched his views about art and the meaning of life. His increasingly abundant correspondence bears witness to this mental activity and progressive self-discovery. At the same time, his work was taking on shape and purpose. Some twenty paintings date from this period, seascapes and woodland views inspired by the wild Drenthe region, which for Northern artists was roughly equivalent to Barbizon for the French painters. He made more and more figure studies of peasants working in the fields; many are found on his letters to Theo. As he was to do at every stage of his life, Van Gogh now entered completely into the environment he had chosen. This time it was an essentially natural setting, rustic and fascinating, especially to a painter's eye. Not that he had forgotten the social preoccupations which were always to underlie his work. Indeed, once more he was soon to share the rude life of peasants and rural artisans, and to leave epic delineation of it. Their figures begin to appear in his Drenthe landscapes. But this wild region in northwest Holland, with its marshland, its bare and scraggly trees, is above all a plant realm where man enters and disappears. The natural environment there reminded Van Gogh of the nobleness, dignity, and gravity in landscapes of Ruisdael and other old masters. In his letters he gives some beautiful descriptions of the countryside he traversed during a canal boat trip to the German frontier and on a cart ride to Zweeloo.

2

"Drenthe province is so beautiful, it captivates me so much, so completely, it satisfies me so absolutely, that if I could not stay here always I would rather I had never seen it." But genuine human contacts seemed more difficult here. The peasants were suspicious and inhospitable, and he who had so fully shared the life of the Borinage miners had to fall back upon his own resources. When the autumn rains set in, he found himself confined to a miserable room, and even out of pigments and brushes. He pleaded with Theo to come and join him; but when the latter refused, Vincent's courage deserted him. Dispirited and penniless, he had no choice but to return to his family. In December 1883 he appeared at Nuenen, where his father now had a parish, in a predominantly Catholic region near Eindhoven. The sudden arrival of this vivid and

eccentric personality, possessed by a passion for painting, indifferent to all conventions of dress and social conduct, produced astonished reactions and soon confrontation. His family, too, showed no understanding whatsoever of his new vocation. He set up his studio in the family washhouse and, taking his meals alone, avoided others as much as possible. He accused Theo of neglecting him. Only Van Rappard came to see him twice, in the spring and fall of 1884. In May, Vincent arranged to rent two rooms from the Catholic sacristan Shafrath and he installed his studio there. Here he began his first important series of paintings, devoted to the daily life of the peasants and weavers of this small village. In treating these two themes, his intent was to follow after Millet, to whose work he had given much thought. He now devoted himself

20

1 Study for first version of "The Potato Eaters."
Nuenen, March 1885. Black chalk drawing, $8^1/_4 \times 13^3/_4$ in.
Amsterdam, Stedelijk Museum.

2 The Potato Eaters. Pen drawing in a letter to Theo from Nuenen, April 1885.
$2 \times 3^3/_8$ in. Amsterdam, National Museum Vincent van Gogh.

3 The Potato Eaters (second version). Nuenen, April 1885.
Canvas mounted on panel, $28^3/_8 \times 36^5/_8$ in. Otterlo, Kröller-Müller Stichting.

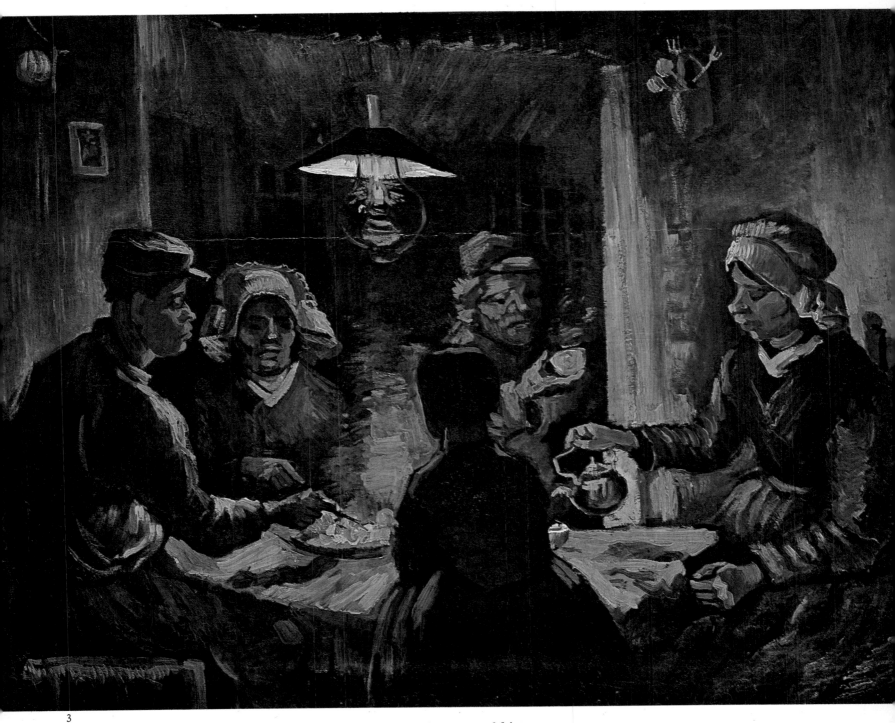

3

wholly to a search for expressivity and, disregarding the advice of Theo, recently won over to the bright colors of the Impressionists, and ignoring his own prior experiments in atmospheric painting, he adopted a palette based on bitumen and bister and browns. Though quite diverse from the artistic tendencies then gaining ground, this restricted color range proved remarkably suited to his powerful linework and the drama

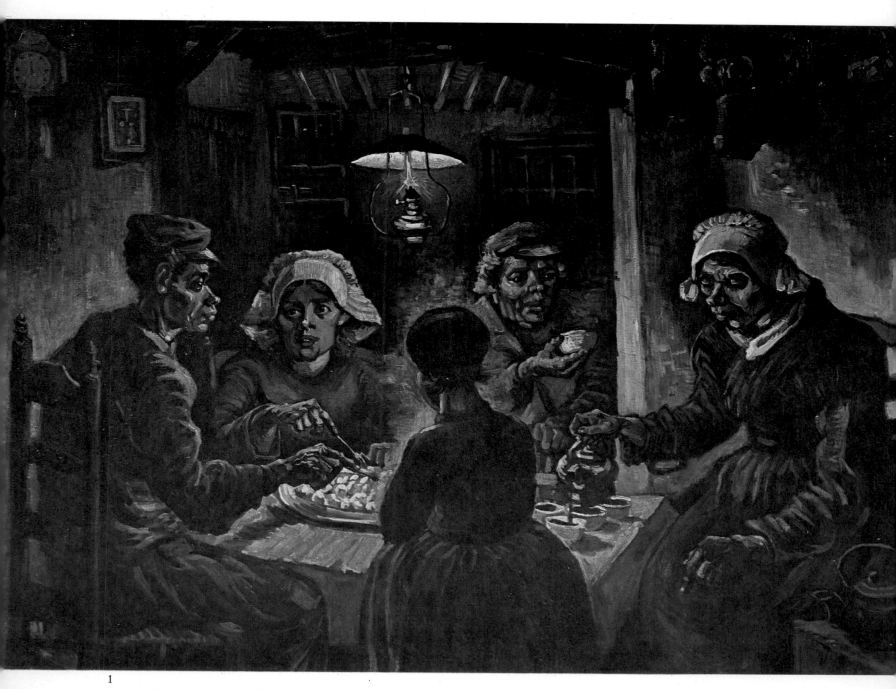

1

he read into the everyday settings and people around him. Some strong whites and broken tones added a valuable touch of luminosity to set off these darker values.

Here he found a style of his own, and his Nuenen period—though not always given due recognition—represents a considerable achievement.

He proceeded deliberately and systematically. He worked and he reworked full-length figures depicted in characteristic movement; he did multiple studies of hands and faces and produced a sequence of fifty peasant heads of remarkable power. When an Eindhoven goldsmith Herr Hermans made it known that he

wished to decorate his diningroom with religious pictures, Vincent suggested instead six scenes of rural life, showing the labors of the fields, in tones harmonizing with the woodwork. Four of the resulting panels have been preserved. In Herman's home he also found motifs for some still lifes, which provided a further

1 The Potato Eaters (third version). Nuenen, April-May 1885.
Canvas, 32$^1/_4$ × 44$^7/_8$ in. Amsterdam, National Museum Vincent van Gogh.

2 Head of a Peasant Woman with a White Cap, study for third version
of "The Potato Eaters." Nuenen, May 1885. Canvas, 17$^3/_8$ × 14$^1/_4$ in.
Otterlo, Kröller-Müller Stichting.

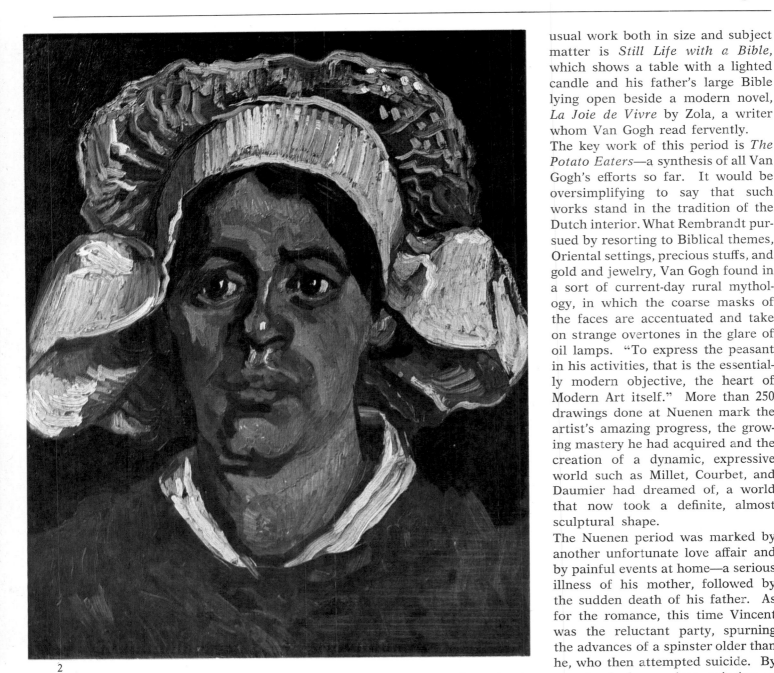

2

challenge for his continuously developing technique. Unlike the old Dutch masters who so often inspired him, he was not attracted by costly or luxurious objects but preferred familiar domestic accessories, simple shapes answering the needs of peasant life: e.g., bottles, jugs, mortars, bowls. Another series of still lifes represent groupings of fruit, potatoes, and birds' nests, whose "variations in grays and browns" assumed in shadowy light a strange and suggestive quality that belied their ordinary appearance. Van Gogh had gathered birds' nests since childhood, and the cupboard of his studio was always full of them. He skillfully reproduced their matted texture of interwoven sprigs and moss. An unusual work both in size and subject matter is *Still Life with a Bible*, which shows a table with a lighted candle and his father's large Bible lying open beside a modern novel, *La Joie de Vivre* by Zola, a writer whom Van Gogh read fervently.

The key work of this period is *The Potato Eaters*—a synthesis of all Van Gogh's efforts so far. It would be oversimplifying to say that such works stand in the tradition of the Dutch interior. What Rembrandt pursued by resorting to Biblical themes, Oriental settings, precious stuffs, and gold and jewelry, Van Gogh found in a sort of current-day rural mythology, in which the coarse masks of the faces are accentuated and take on strange overtones in the glare of oil lamps. "To express the peasant in his activities, that is the essentially modern objective, the heart of Modern Art itself." More than 250 drawings done at Nuenen mark the artist's amazing progress, the growing mastery he had acquired and the creation of a dynamic, expressive world such as Millet, Courbet, and Daumier had dreamed of, a world that now took a definite, almost sculptural shape.

The Nuenen period was marked by another unfortunate love affair and by painful events at home—a serious illness of his mother, followed by the sudden death of his father. As for the romance, this time Vincent was the reluctant party, spurning the advances of a spinster older than he, who then attempted suicide. By now he had gone into painting as one takes holy orders, and he lived only for his art.

Viewed in the perspective of Van Gogh's work as a whole, the Nuenen period occupies a position of lesser importance. Though its formative significance and value are recognized, it is usually considered as the last stage of a painful and difficult search,

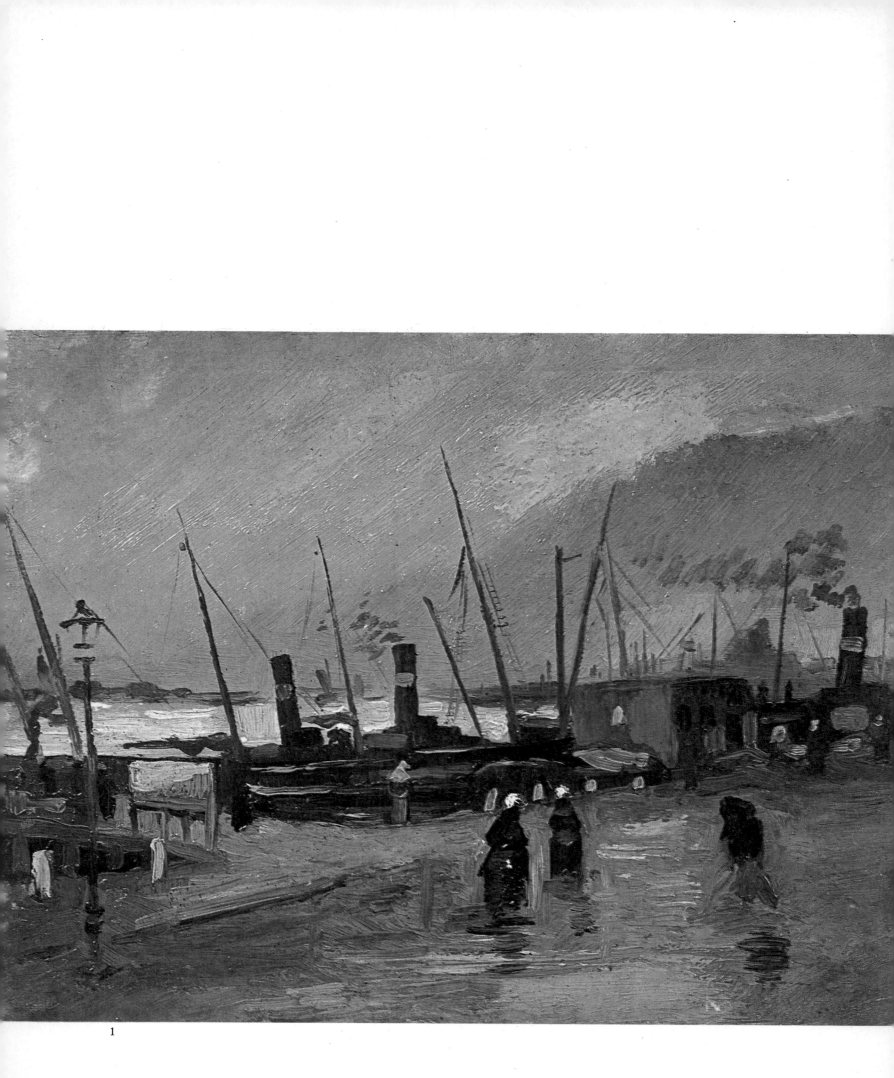

1

1 **The Antwerp Quay.** Antwerp, December 1885.
Canvas, 8 × 10⅝ in. Amsterdam, National Museum Vincent van Gogh.

2 **Portrait of a Young Woman in Side View.** Antwerp, December 1885.
Canvas, 23⅝ × 19¾ in. U.S.A., Private collection. (Photo Giraudon)

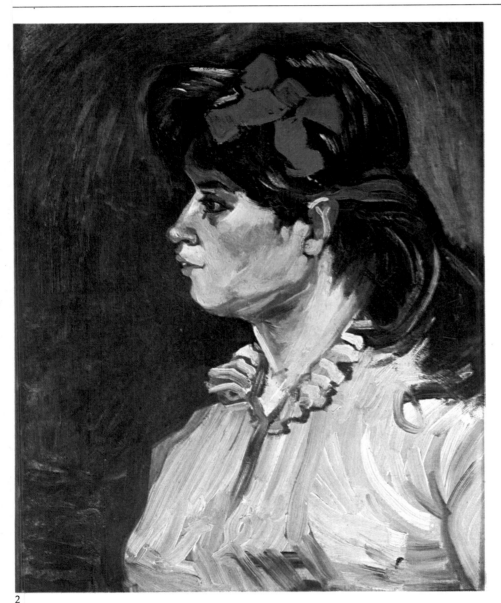

2

before the crowning illumination that came to him through the light of Paris and, above all, his discovery of the Midi. In France, too, he was to become friends with some of the foremost artists of his time—indispensable contacts for him, yet among whom he could now hold his own without any sense of inferiority. Still, it seems to me, already at Nuenen he had found himself fully, not only in his pictures, which include some notable works, but in his whole approach to his art. The way he carried through his ideas, to the limits of their possibilities, indicates a new inner confidence in strong contrast to the doubts and hesitations of the past. He had become the secure painter of a world he knew well and belonged to, so that one wonders what his remaining work would have been like had he ceased his perpetual wandering, stayed in Holland, and further developed the expressive manner of this phase. His work would probably have been less tormented and agitated, fulfilling itself in the form of its expression. Everything since achieved in this mode by Northern painters and the German Expressionists has its source in Van Gogh's work, where it had already come to fruition. But, from this time on, Van Gogh did not limit himself to objective delineation or strict composition. He painted from within, and it is this inner glow emanating from the heart of his pictures, and in the pigments themselves, which transforms even humble appearances and which thus gives the most modest of his works a truly universal significance. At this time Van Gogh was particularly imbued with Delacroix and Daumier, as well as with Michelangelo and the aesthetic opinions of Baudelaire, and he caught the epic aspect of daily life and the grandeur of modern times.

The circumstances of his life do not quite explain Van Gogh's departure for France—from which there was to be no return—and his renunciation of all that had mattered to him till then. There was a brief transitional sojourn in Antwerp, where he made two important discoveries: his eyes were opened to the Oriental fascination of Japanese prints, which he pinned on the walls of his room, and to the bold technique of Rubens, whose pictures he pondered long in churches and museums. He enriched his palette, prior to this deliberately restricted, with the splendors of emerald, cobalt blue, and carmine. His stiff brushwork became freer and gave to his colors a more fluid, animated quality that resulted in a noticeable broadening of his vision. He now looked more searchingly at faces—"I would rather paint the eyes of men than cathedrals"—and first of all at his own, so beginning the extraordinary series of self-portraits in three-quarter view, with their tormented eyes.

2 - PARISIAN IMPRESSIONS

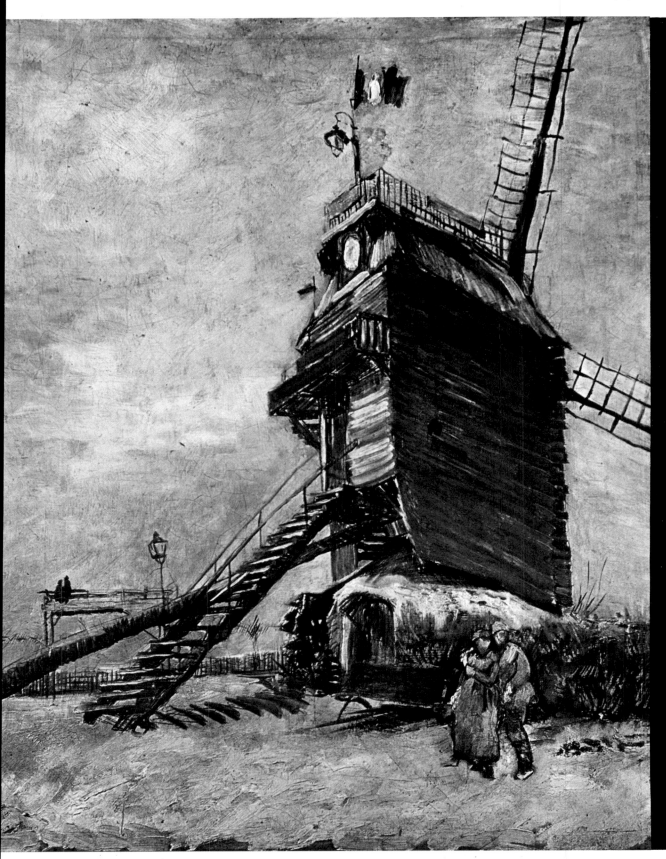

Le Moulin de la Galette.
Paris, winter 1886-1887.
Canvas, 24 × 19³/₄ in.
Buenos Aires, Museo Nacional
de Bellas Artes.

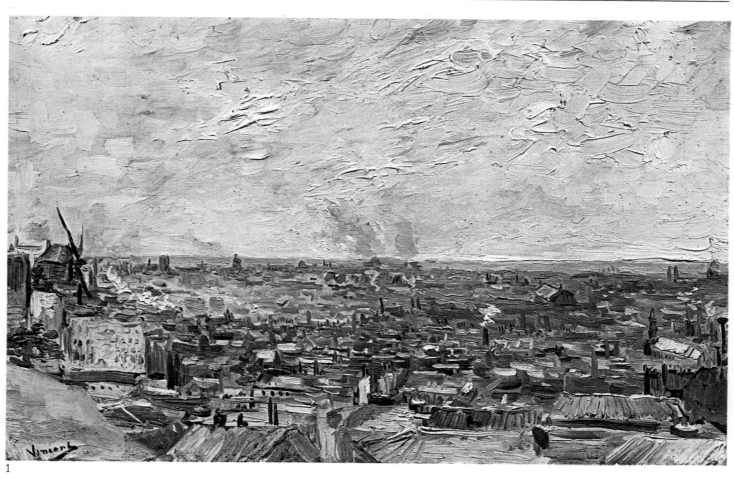

1

Since their father's death in 1885, Vincent had wished to live nearer his brother Theo. In February 1886 he joined him in Paris, where he was to spend the next two years. Theo, whose apartment he shared in Rue de Laval (today Rue Victor Mercier) near Pigalle, both filled his family role and acted as Vincent's intermediary with the Paris art world, at a time when much was happening there. Having no place to paint in their small apartment, Vincent at once enrolled in the neighboring art school of the painter Cormon, where he went every morning to work from live models. Among the students he became friendly with at Cormon's were the young Henri de Toulouse-Lautrec, who made a fine portrait of Van Gogh, and another southerner, François Gauzi, who left an interest-ing account of Van Gogh's feverish way of working, never pausing even during the model's rest periods and keeping at it even after the sitting was over. And he would come back in the afternoon to work alone from plaster copies of ancient statuary, wearing holes in the paper with his incessant erasing and corrections. Among the other fledgling painters attending the school were Louis Anquetin and the Australian John Russell, who was to become a friend of Monet and Rodin, and to give the young Matisse, besides advice, two drawings by Van Gogh.

Through his brother, Vincent made many other contacts. Theo had become manager of Goupil's Montmartre branch (now belonging to Boussod and Valadon) and was in personal touch with the major Im-pressionists, whose canvases he had begun to show in his mezzanine gallery. Theo also recognized—as few then did—Daumier's genius as a painter, and he had business rela-tions with the English dealer Alexan-der Reid, a great admirer of Monti-celli. The latter had just died men-tally unbalanced in Marseilles, but his colorful canvases could be seen at Delarbeyrette's, a dealer in Rue de Provence. André Bonger, a cus-tomer and friend of Theo and soon to become his brother-in-law, was a fervent admirer of Odilon Redon, who just at that time was drawing closer to the Impressionists. In May and June 1886, the latter held their eighth and last group exhibition, which both confirmed their decisive contribution and marked the break-up of their original core and its

28

3

2

subsequent renewal through a more scientific application of Impressionist theories. Seurat, with *La Grande Jatte*, was the star of this last exhibition, and Pissarro was won over to his ideas. The other great pole of attraction was Gauguin, who, in going beyond surface impressions, aimed at self-expression in symbolic terms. Degas exhibited a series of female nudes at their toilette, in which he renewed and enriched the pastel technique. Odilon Redon for the first time showed his black-and-white drawings. Monet, Renoir, and Sisley did not participate. It was only natural, then, that Van Gogh should look to the new painters who in his eyes were linked directly with two artists he had long admired: Millet and Daumier. Of the artists he then met, he was most attracted by the personality of Pissarro, looked up to by all for his integrity and sound judgment. Van Gogh was thus impelled to follow Pissarro's example and, in the same intuitive and sensitive way, to adopt the Neo-Impressionist manner.

Van Gogh applied that approach in some works inspired by his growing awareness of the Parisian townscape. The two brothers had moved to 54 Rue Lepic, on the slopes of Montmartre, where they occupied a spacious fourth-floor apartment with

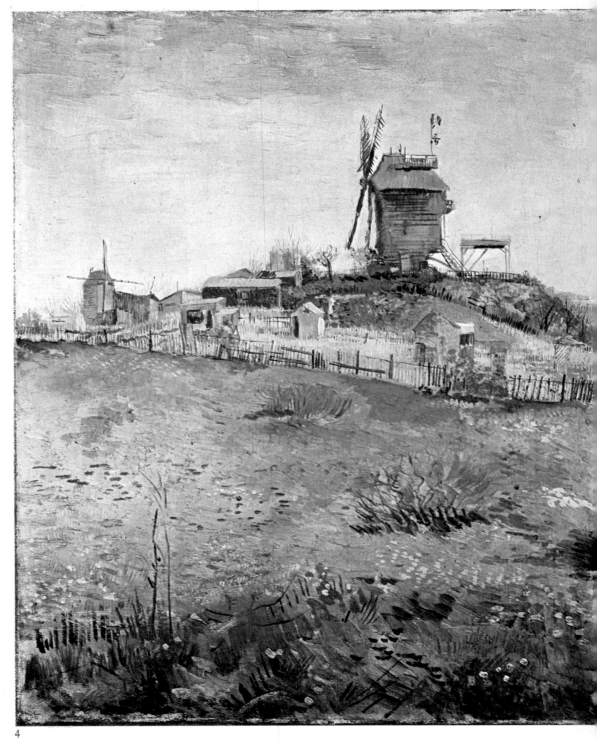

4

a sweeping view over the Parisian rooftops. Vincent no longer frequented Cormon's studio and set about painting the panorama from his window and the different aspects of Montmartre, then still a village with a distinct identity. He rambled through its streets daily; reminding him of the Holland of his youth, its rustic houses, gardens, vineyards,

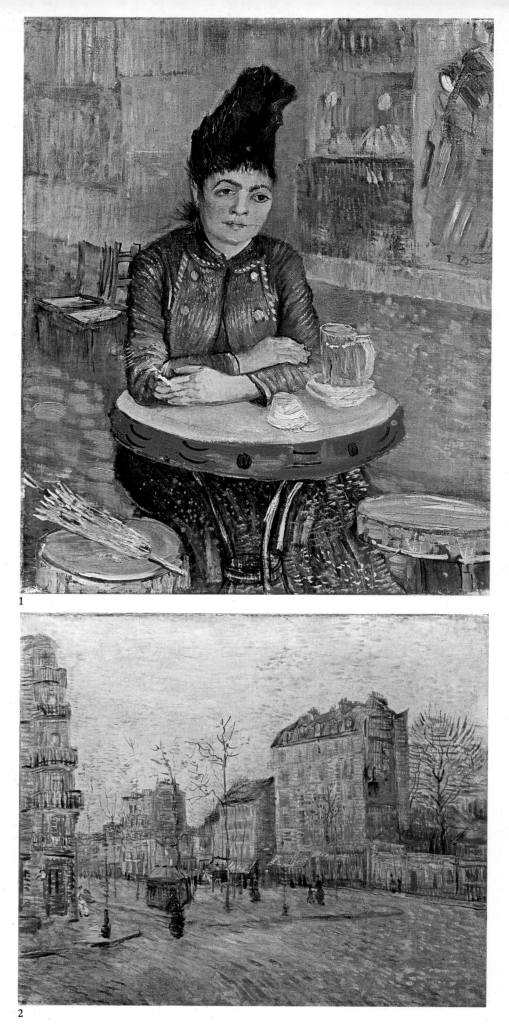

and windmills inspired and enchanted him. And in the brilliant light of this sun-drenched hill, his palette soon changed and brightened.

Very few artists have been as responsive as Van Gogh to the atmosphere around them, and to the moral and intellectual climate as well. This is evident even in the means he employed, which he varied so freely despite the persistent underlying rhythms that characterize his work. The recent large Van Gogh exhibition held in Paris presented valuable testimony of this era in the city's history, with intimate glimpses of secluded landscape and out-of-the-way corners, smoking factories, bucolic lanes, festive little gardens, and humble façades bathed in sunlight. Their subjects are almost lost sight of in the magic of their color, but these unpretentious pictures are not minor works. They mark a more intimate, searching approach to the painter's new environment, as he gradually became imbued with and mastered it. At the same time he painted some brilliantly colored flower pieces, some still lifes of common homely objects, and a series of self-portraits in which he carefully analyzed the star-shaped plane of his face. The structure of the human body called for a consistent, elongated brushstroke, capable at once of describing summarily, and even brutally, the volumes of body, clothes, and setting and of capturing with precision the nuances of individual features, in particular his own bearded face, its intense eyes and luminous brow set off by various headgear.

Van Gogh was already a great painter, but he was and remained above all a man of ardent feeling, uncompromising in his likes and dislikes, passionate and wholehearted in his friendships. Bursts of enthusiasm and of generosity alternated in him

1 **Seated Woman at the Cabaret "Au Tambourin."** Paris, February 1887.
Canvas, 21⅞ × 18⅜ in. Amsterdam, National Museum Vincent van Gogh.

2 **Boulevard de Clichy.** Paris, February-March 1887.
Canvas, 18⅜ × 21⅝ in. Amsterdam, National Museum Vincent van Gogh.

3 **Reclining Female Nude.** Paris, first half of 1887.
Canvas, 15⅛ × 24¼ in. France, Private collection.

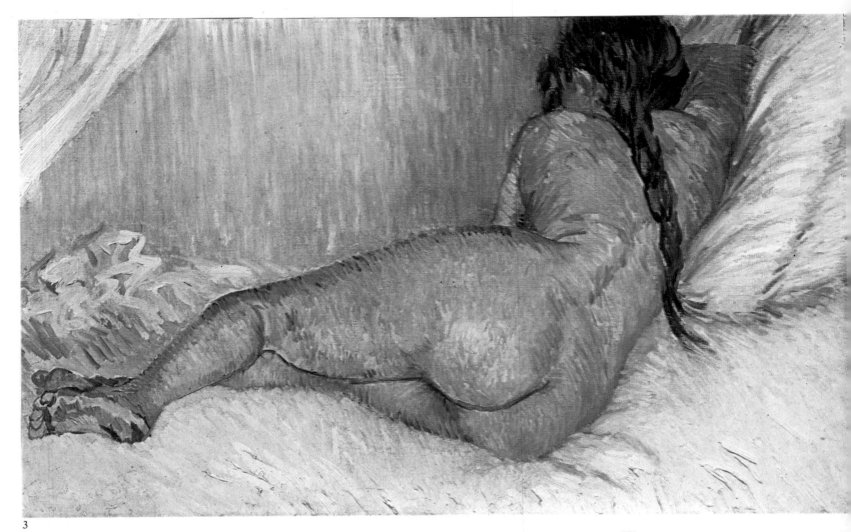

3

with fits of anger and of irritation. Theo had a lot to put up with. "The flat is almost untenable," he wrote to his sister. "It is as if there were two beings within him—one marvelously gifted, delicate and tender, the other selfish and hardhearted. . . . What a pity he should be his own enemy." Vincent became acquainted with the painter Guillaumin, who had noticed his canvases and drawings left in storage with a neighbor, the dealer Portier. Guillaumin, who often invited Van Gogh to his studio in Ile Saint-Louis, liked and admired him, yet grew to fear his temperamental outbursts—ferocious discussions that reminded him of Tasso raving among the madmen, impossible to restrain.

Through Theo, Vincent also met Gauguin, just back from a painting trip in Brittany. And Vincent fell at once under the spell of Gauguin's vivid personality and was impressed by the power and grandeur of his work. This influence made itself felt a little later, when Van Gogh found in the Midi the colors and pictorial climate answering to his new outlook.

During the winter of 1886-1887 he became friendly with Père Tanguy, a kindly old man and former Communard who had a small paint shop in Rue Clauzel. Tanguy ground his own colors and would often exchange them for his customers' canvases—then practically unsaleable but now the glory of the world's

great museums. His customers were his friends, for whom he would extend credit and gladly show their work in his shop. There Van Gogh met Paul Signac and Charles Angrand, who furthered his acquaintance with Pointillism; there, too, he met Émile Bernard, the friend and rival of Gauguin. And through these men he became familiar with the two main trends of avant-garde art of the moment, for Impressionism had passed its zenith. At the international exhibition held in 1887 at the George Petit Gallery, now become the great competitor of Durand-Ruel, Renoir showed his large *Bathers*, which marked a return to a linear, Ingresque concept of painting. Refusing to exhibit at the Salon

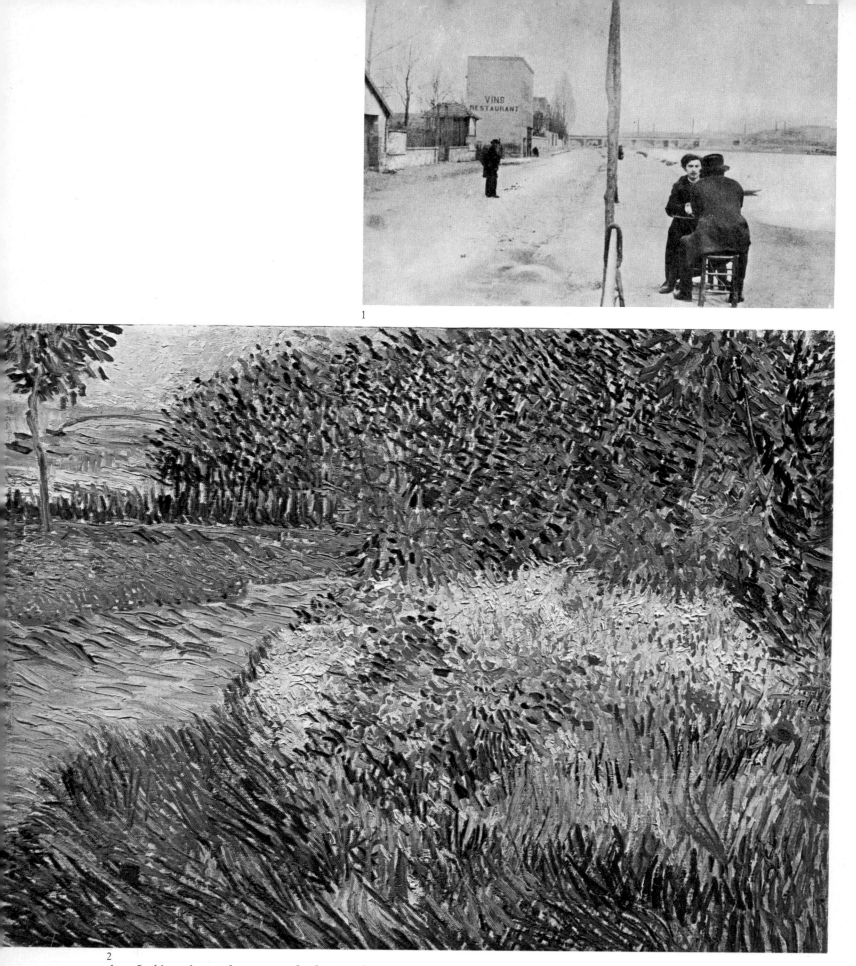

1

2

des Indépendants because of the feud that had erupted there between Émile Bernard and Seurat's supporters, Van Gogh organized an exhibition in a Clichy restaurant, including about a hundred of his own canvases together with others by Bernard and the Dutch painter A. H. Koning. Other artists came to have a look, among them Seurat, who met Van Gogh there for the first time. But after quarreling with the restaurant owner, Vincent was ordered off the premises and hastily had to cart away all his canvases, back to his Rue Lepic apartment. He made another attempt—again a failure—to exhibit at a cabaret in Boulevard de Clichy called "Au Tambourin," which was frequented by Lautrec and run by a former artists' model, Agostina Segatori, of whom Van Gogh made a portrait. Two similar works by Lautrec and Van Gogh showing a young woman sitting at a table in the cabaret give testimony of the artists' patronage.

There was, indeed, a genuine kinship and sense of fraternity between these two men, so different in background, training, and aims. Both were extremely sensitive figure painters, tenderly capturing the mood and

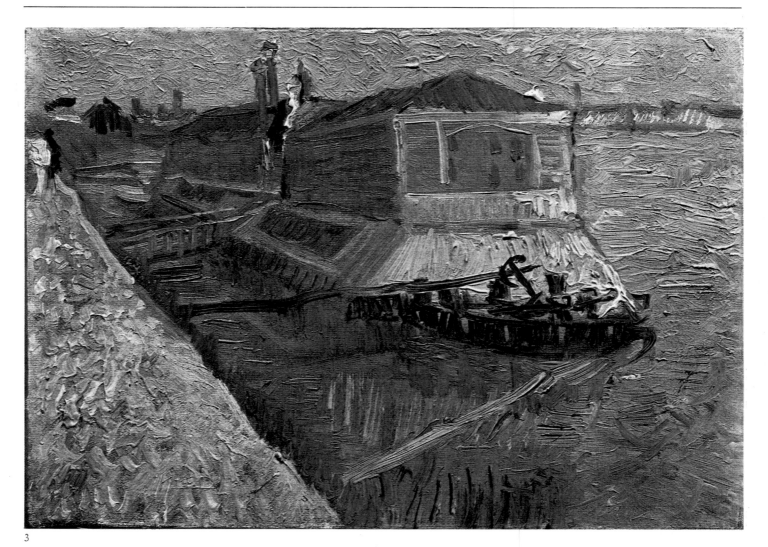

3

character of the sitter with short, enveloping brushstrokes. Both artists liked, understood, and respected these social outcasts they so often portrayed, whose life they shared and whose basic dignity they had the insight to perceive and record. Done soon after they met, Lautrec's portrait of Van Gogh shows the Frenchman's sympathetic understanding of his Dutch friend. This work, though it has all the characteristics of Lautrec—the sharp profile, the slashing linework with its turning and twisting strokes—still comes remarkably close to Van Gogh's own self-portraits and might almost take its place in that series.

As for Van Gogh himself, when he practiced orthodox Pointillism, he did so in his own passionate manner, breaking away decisively from the cool control of Seurat, whom he greatly admired, nonetheless, and made a point of visiting once more before leaving Paris for the Midi. His Paris townscapes, with their fragmented brushstrokes and contrasting colors, have a fresh spontaneity that clearly differentiates them from the visual approximations of the Impressionists and the more systematic optical analyses of the younger Indépendants.

In pursuing his personal investigations, Van Gogh was always anxious to compare notes with other painters. His nature demanded communication and confrontation, for his was always the soul of an apostle. The Impressionist movement had now broken up, and to replace it he dreamed of establishing in Theo's Montmartre gallery a new artists' commune, grouping together such disparate personalities as Gauguin, Bernard, Seurat, Signac, and Lautrec. He saw himself as their connecting link, encouraging their frank exchange of ideas, helping to stimulate their expressive powers, and ensuring their material well-being. Thus when Gauguin, ill and penniless, returned from his first

voyage to the tropics (to Martinique in 1887), Vincent urged Theo to buy his canvases and the souvenirs he had brought back.

Though he found a new happiness in living with his brother, his dependence on him gave Vincent a feeling of guilt with respect to his friends, most of whom were poor and as yet unrecognized. He saw himself as a burden on Theo, a responsibility that was holding him back. He foresaw and dreaded his brother's eventual marriage and decided to go off on his own again. He made secret preparations to leave

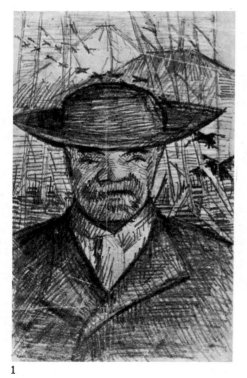

1

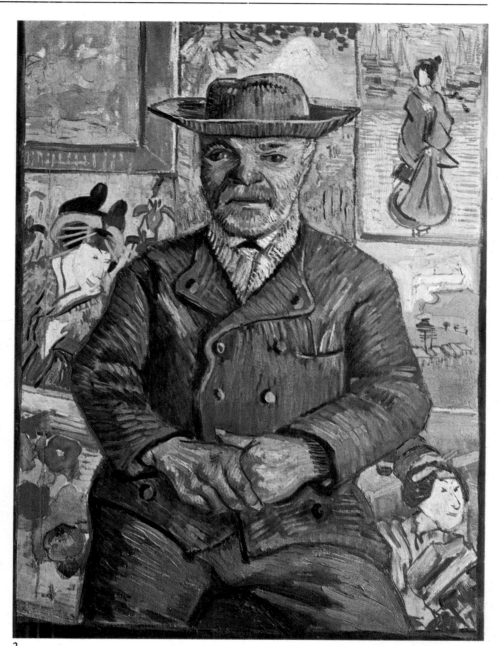

2

for the South of France, just as Gauguin, with whom he now had a close relationship, was setting out again for Brittany.

The two years Van Gogh spent in Paris were the happiest of his life, the richest in human contacts and personal development. He had been able to compare his own work with that of the most able and intelligent artists of his time; he saw great

artistic achievements taking place before his eyes and played a not inconsiderable part in them himself. He painted his first masterpieces, the *Portrait of Père Tanguy* against a background of Japanese prints and several fine self-portraits, including the one with his easel. He painted some fifty flower pictures—"red poppies, blue cornflowers, forget-me-nots, pink and white roses, yellow

chrysanthemums, white lilacs on a black ground, orange tiger lilies on a blue ground, violet dahlias on a yellow ground, red gladioli in a blue vase on a light-yellow ground"—comprising one of the finest series of this type in the history of painting, ranking alongside those of Fantin-Latour, Monticelli, and Renoir. An almost equal number of landscapes in oblong formats evoke the daily

life of Montmartre in different seasons and also show the Paris suburbs, where Van Gogh went out working in the spring and summer of 1887 with Émile Bernard, who had built a studio in the garden of his parents' house at Asnières. This was Vincent's first contact with the French countryside. Bernard has described him setting off with a large canvas on his back, which he then divided up into small compartments in which he noted anything that caught his eye as he walked along. Van Gogh's relations with the Neo-Impressionists are now judged to have been of great importance for him, both technically and personally. The friendly relations he established with them meant much to this anxiety-prone creative spirit, so eager to communicate. The reassuring presence of Seurat, with whom he went out painting the island of La Grande Jatte; the researches of Anquetin, from whom he learned much about using sun-yellow and night-blue; and above all, his close contact with Signac—all these gave Vincent a confident sense of sharing in the most important developments of contemporary painting, even though his own efforts were autonomous and apart from the collective activities of the group. He was especially stimulated by Signac, and the Dutch critic A. M. Hammacher has pointed out how similar Van Gogh's Parisian still lifes are to those of Signac. In delineating objects viewed at a steep angle, Van Gogh was less concerned with divisionist fragmentation than with cross-rhythms patterning the surface and accents heightening the expression. He was influenced in this direction by his growing appreciation of Japanese art. For some years he had been collecting Japanese woodblock prints and sought to transpose their light and shifting patterns into the denser oil medium. In Japanese

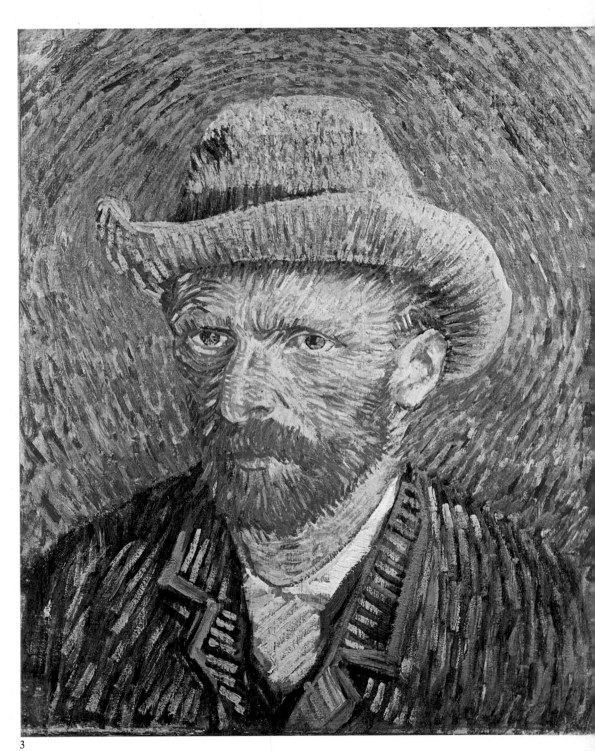

3

art, where the technical means always served to convey a terse spiritual message, he found a precedent for his own ideas about the social role of art. When he left for Provence, a land of which he knew nothing but dreamed of as an oasis, Garden of Eden, a private "Orient," he went in the hope of finding there "the equivalent of Japan."

3 - THERE IS NO PARADISE

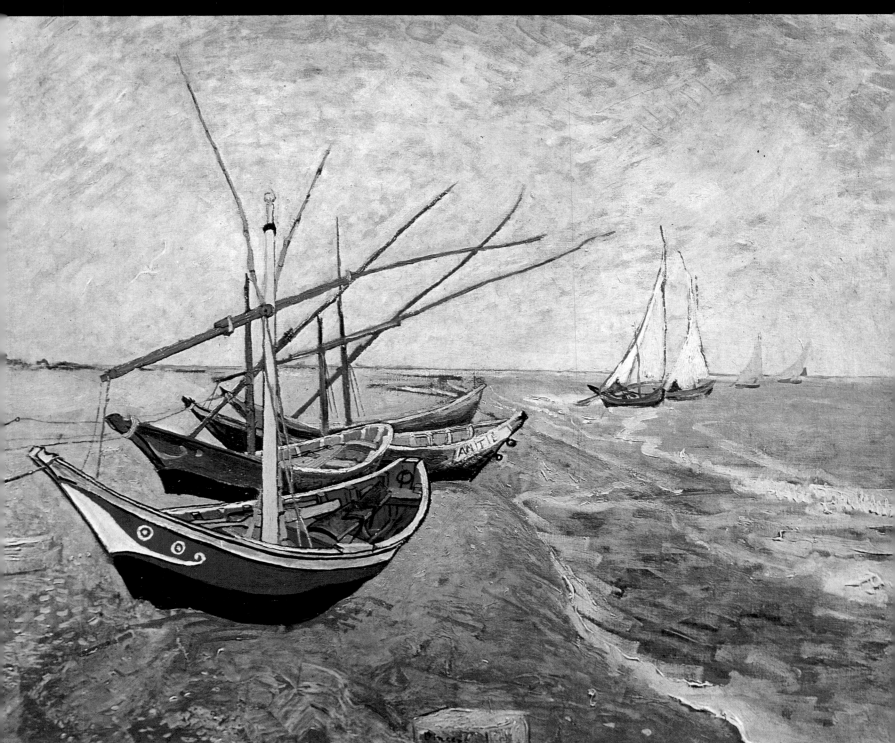

Boats at Saintes-Maries. June 1888. Canvas, 25$^1/_4$ × 31$^7/_8$ in.
Amsterdam, National Museum Vincent van Gogh.

1 **The Bridge of Langlois. Arles, March 1888.**
 Pen and India ink drawing, 9¼ × 12¼ in.
 Los Angeles County Museum of Art, Mr. and Mrs. George Gard De Sylva Collection.

2 **The Bridge of Langlois.**
 Drawing in a letter to Émile Bernard from Arles, March 1888.
 Amsterdam, National Museum Vincent van Gogh.

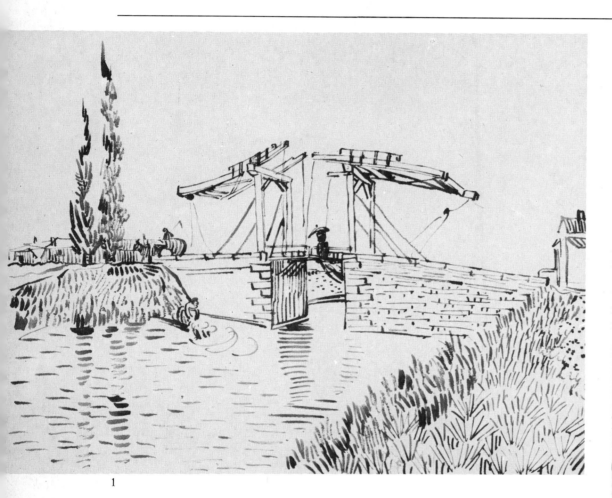

1

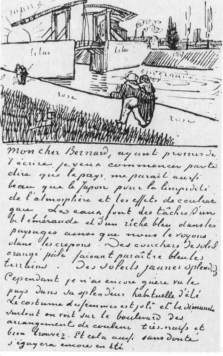

2

A miracle! When Van Gogh arrived in Arles on February 21, 1888, he was surprised to find Provence blanketed with snow. And when it melted away and the almond trees burst into bloom, it was as if the snowflakes had reappeared on their branches. It is not known why he chose Arles, but he could hardly have found better than this attractive town, still so close to its beautiful countryside. Its promenade of Les Alyscamps meandered peacefully among Roman tombs shaded by cypresses and olive trees; and beyond was the great plain of La Crau, where the hot sun ripened the wheat and fevered the brain. But Vincent saw it first in spring, under cloudless skies so limpid that it made him think he had found his paradise at last, the ideal place to establish the artists' community of which he had dreamed.

He took an attic room in a small hotel-restaurant at the entrance to the town, and from his window overlooked the ramparts and adjoining countryside. Since his quarters were cramped, he usually painted outdoors, and was fascinated by the sharp outlines given to the trees and vegetation by the slight chill. When the fruit trees budded in April, he worked steadily at painting their brief flowering, captivated by their beauty and fragility. In mid-May he found a four-room apartment in Rue Lamartine, where he could live more economically and fill the walls with the canvases he was accumulating. In early June he traveled to Saintes-Maries-de-la-Mer, along the Mediterranean coast, where he discovered a violet sea such as he had never imagined. He was enchanted by the white houses of the locality and the women, "as majestic as the figures of Cimabue and Giotto."

When he returned to Arles it was summer, and its dense pure colors reminded him of "old gold, bronze, and copper." He painted for hours in the wheatfields under a blazing sun, possessed again by the image of Millet's *Sower*. But he himself was now the sower, finally scattering the seed of a rich harvest. For him extremes met: the sun-scorched wheatfields or stones found echo in the remote depths of night. He plunged into the cool, all-enveloping night as into a refreshing bath; the thousands of its glittering stars seemed close enough to touch. In a strange getup, his hat crowned with a circle of small lighted candles, he set up his easel on the banks of the Rhone and painted the *Starry Night*. Over the

38

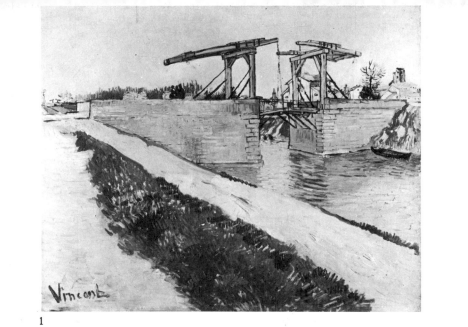

1

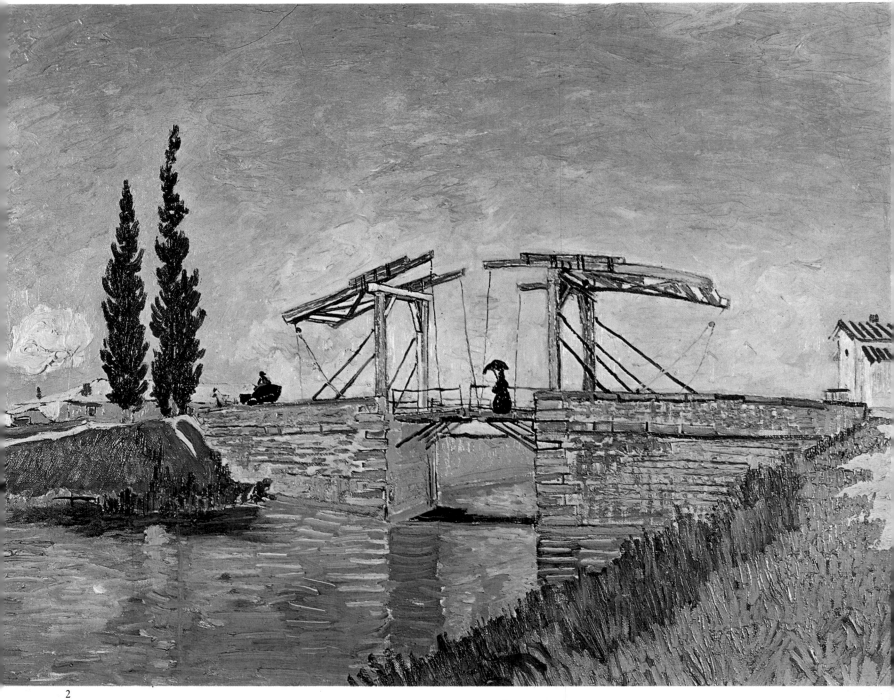

2

1 The Bridge of Langlois. Arles, March 1888. Canvas, 23 × 28³/₄ in.
Amsterdam, National Museum Vincent van Gogh.

2 The Bridge of Langlois. Arles, May 1888.
Canvas, 19¹/₂ × 25¹/₄ in. Cologne, Wallraf-Richartz Museum.

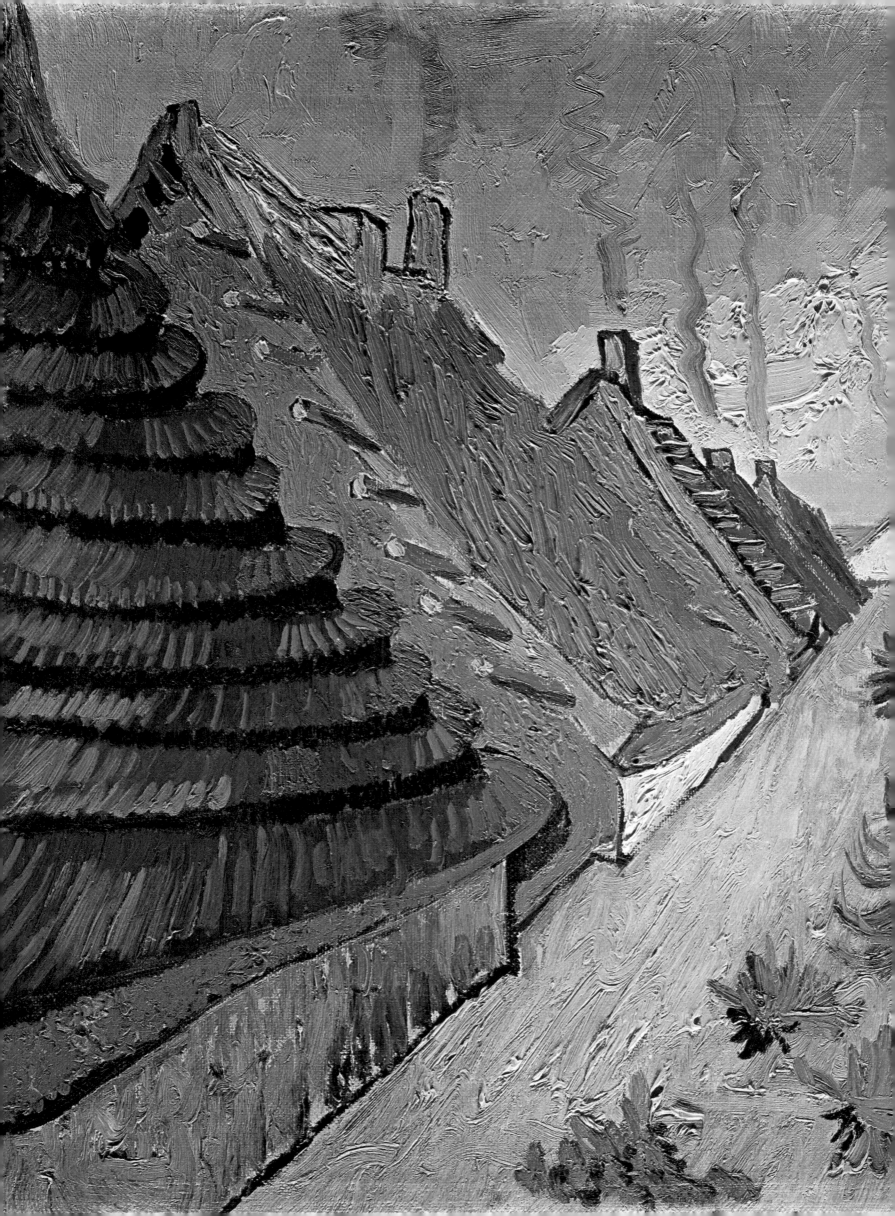

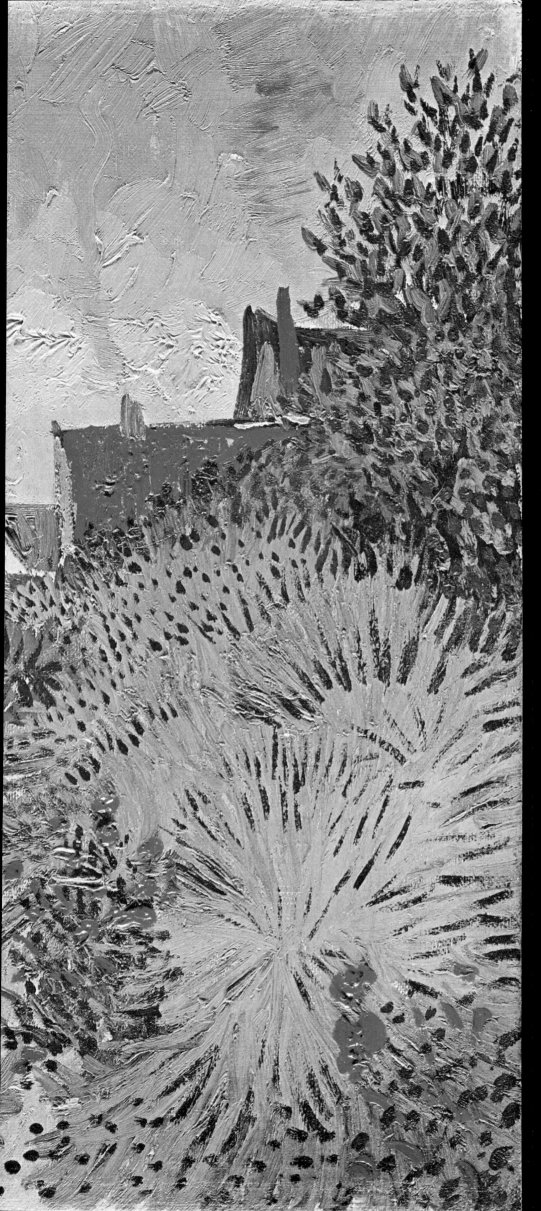

Houses at Saintes-Maries.
June 1888. Canvas, 14³/₈ × 17³/₈ in.
U.S.A., Private collection.

1

Outdoor Café at Night the stars shine like night flowers in the heavens. But even in his daytime landscapes, his views of Arles and the house where he lived (the "Yellow House"), the sky has the same somber luster. Against the quite neutral ground of his portraits the colors stand out, all the more vividly in the flat tones of clothes and the pink or olive flesh tints. Within a few weeks in this new clime he had forgotten the shifting colors and nuances of Impressionism. Nothing could check the fury within him. The strongest colors, he felt, "should be used boldly," knowing that "time will only soften them too much." And indeed, for all the care with which Van Gogh's canvases have been preserved, it has often been noticed by today's museum-goers most familiar with them that the passing of time has produced an alteration in their colors.

3

In August 1888, Vincent made the acquaintance of the postman Roulin, who became a sincere friend and of whom he made an admirable portrait. He also made some fine portraits of the café proprietress Madame Ginoux, dressed in traditional Arles costume. On September 18 he moved into the Rue Lamartine apartment which he had arranged and furnished himself, hoping to make it the "house of friends." There he received Gauguin, the first of his friends to be invited. Theo had encouraged this visit, for he hoped the two friends would help each other

4

2

and live more economically by sharing the same home; he had also contributed whatever he could to furnishing the house. Theo had just signed a contract with Gauguin, and with the remittances he sent regularly to his brother it seemed that the two painters should manage fairly well. Since leaving Paris and

its artistic companionship, Vincent had led a lonely life at Arles and looked forward eagerly to Gauguin's arrival. His suppressed excitement became alarming. He looked up to Gauguin and saw in him the unchallenged leader of that "studio of the Midi" he dreamed of; yet at the same time, before his friend arrived, Vincent was anxious to build up abundant evidence of his own technical ability, originality, and ideas. Gauguin arrived in Arles on October 23, 1888. The two men were delighted to see each other and exchange news of their Parisian friends and their own work. But with two such strong and disparate temperaments, the atmosphere was soon heavy with a veiled hostility; they could not seem to agree on anything. Gauguin

found fault with Van Gogh for admiring Daumier and for his romantic leanings, while he himself yearned for a "primitive state." After an excursion to Montpellier to visit the Musée Fabre, they had a violent quarrel over Rembrandt. Van Gogh was too much in awe of Gauguin to ask him to pose, but Gauguin did a portrait of Vincent painting the sunflowers of which he was so fond. "It's me, all right," admitted Van Gogh, "but me turned into a madman." Hopes of happy comradeship and common endeavor soon vanished. Gauguin grew restless and talked of returning to Paris; Van Gogh then begged him to stay. Finally, Christmas Eve, the storm broke. After drinking absinthe they quarreled violently, and Van Gogh threatened

2

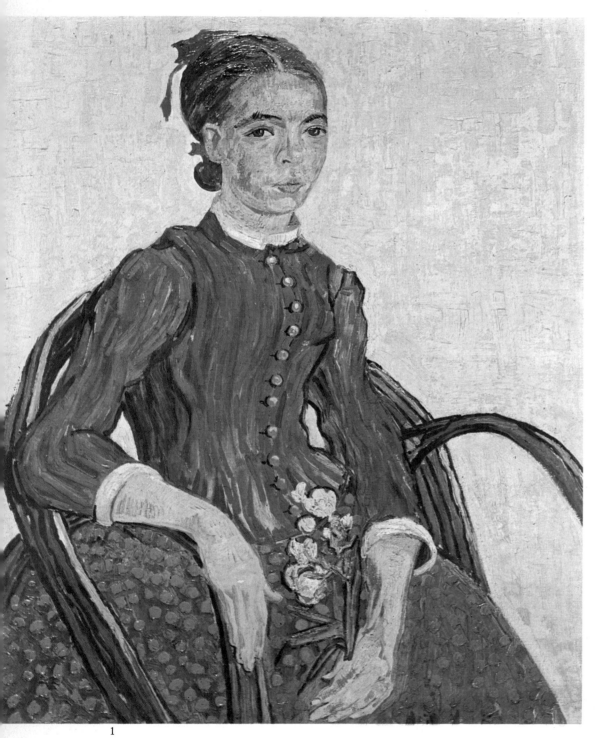

1

Gauguin. The next day the tension mounted, and Gauguin left the house with the idea of moving to a hotel. Hearing jerky footsteps behind him, he turned around to find Vincent following him like a sleepwalker, with a razor in his hand. Jolted to his senses by Gauguin's stern gaze, Van Gogh turned and hurried back to the house. Once there, he went to his room, sliced off part of his left ear with the razor, washed it and wrapped it carefully, and then took it to one of the girls at a brothel he sometimes visited. His appearance there and in the streets, with bloodstained towels wrapped around his head and capped by a beret, caused a stir of excitement and the police were called.

Meanwhile Vincent went home again, stretched out on his bed, and lost consciousness. When he came to, his mind was clear and he asked for Gauguin. The latter, who was at first suspect when the neighbors saw bloodstains in the stairway, had already taken the train back to Paris. Van Gogh was taken to St. Paul's Hospital and treated considerately by a young doctor named Rey, who was among the first to perceive his true genius. He soon recovered and, on January 1, 1889, was allowed to go for a walk with his friend the postman Roulin. He wrote a letter to Theo on which Dr. Rey added a few reassuring lines, and there was even a friendly message for Gauguin. Vincent was released on January 7, though he still had to call at the hospital daily to have his wound dressed. He returned home and at

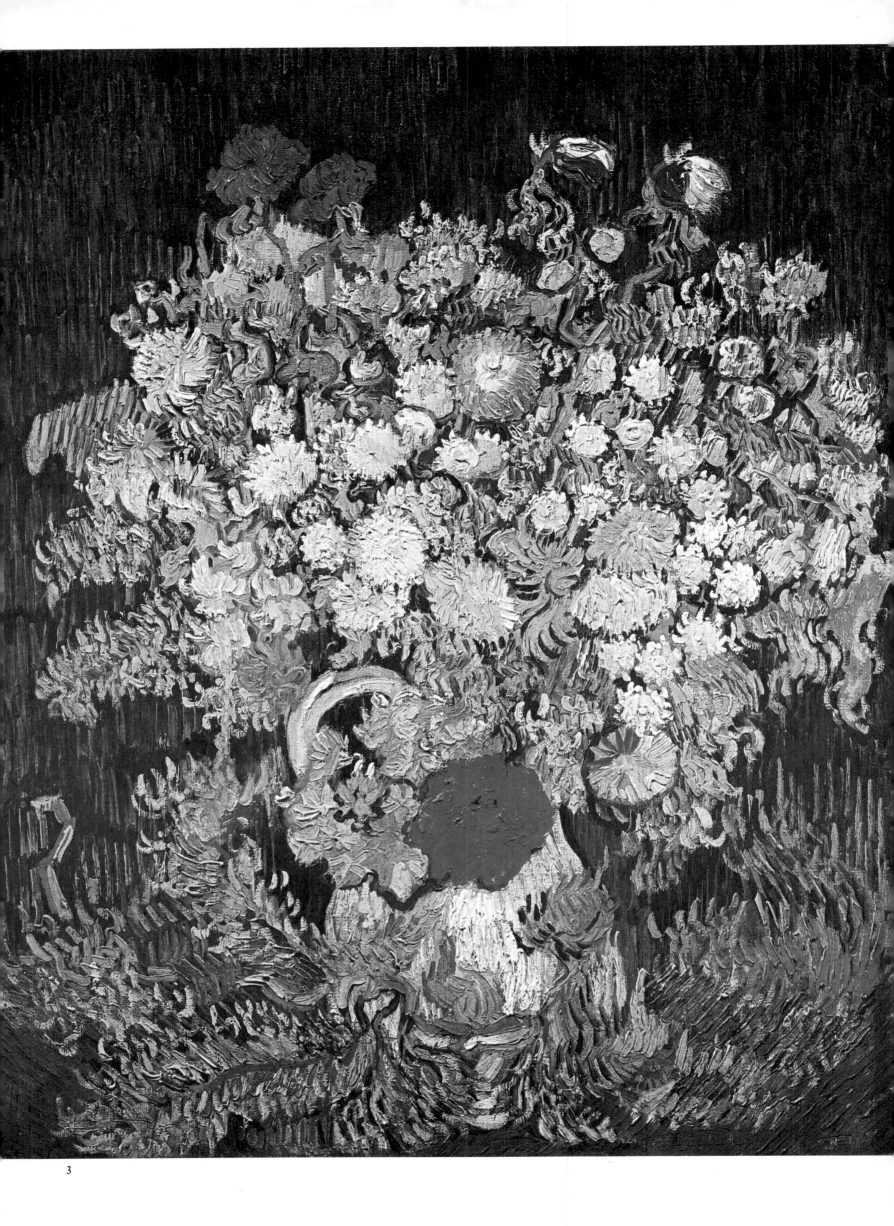

3

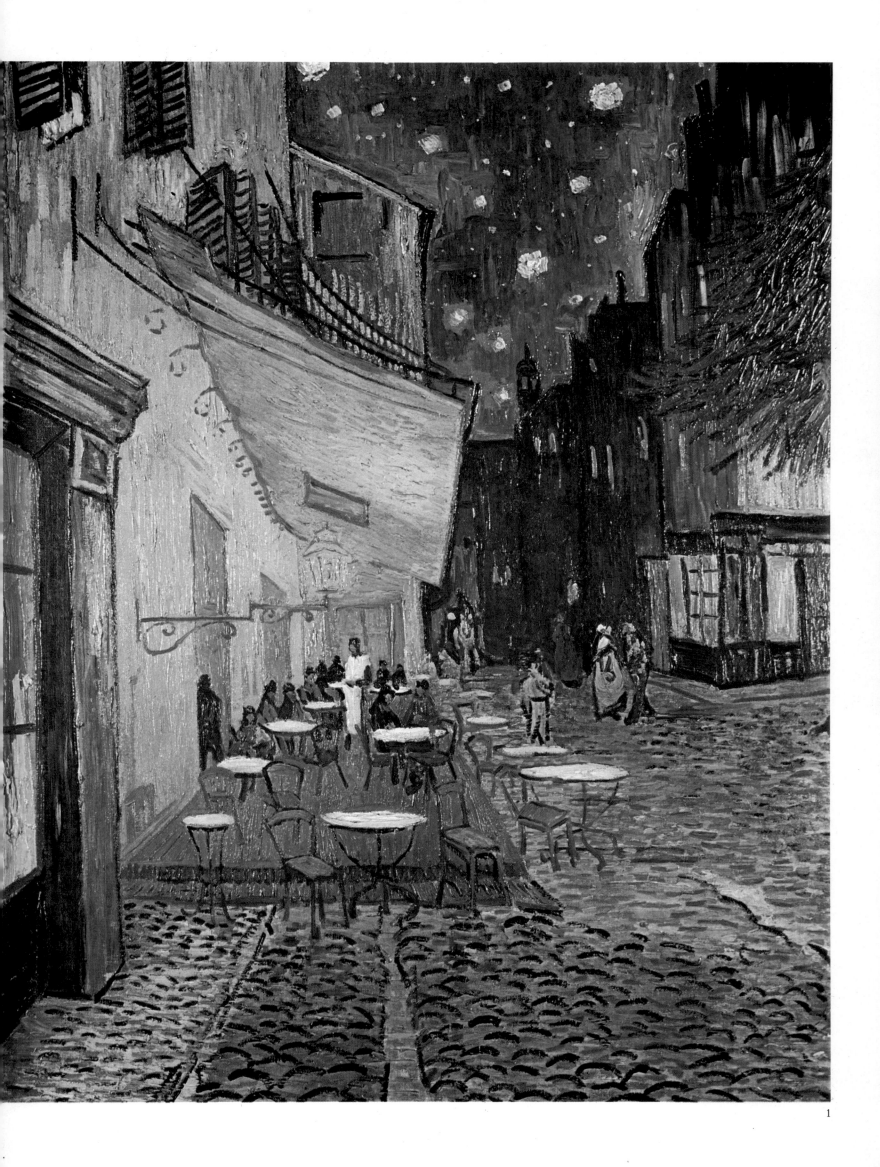

1 **Outdoor Café at Night. Arles, September 1888.**
Canvas, $31^7/_8 \times 25^3/_4$ in. Otterlo, Kröller-Müller Stichting.

2 **The Night Café. Arles, September 1888. Canvas, $27^1/_2 \times 35$ in.**
New Haven, Conn., Yale University Art Gallery.
Bequest of Stephen Carlton Clark, B.A. 1903.

3 **The Night Café. Arles, early September 1888. Watercolor, $16^1/_2 \times 24^1/_4$ in.**
Bern, Private collection. (Photo G. Howald)

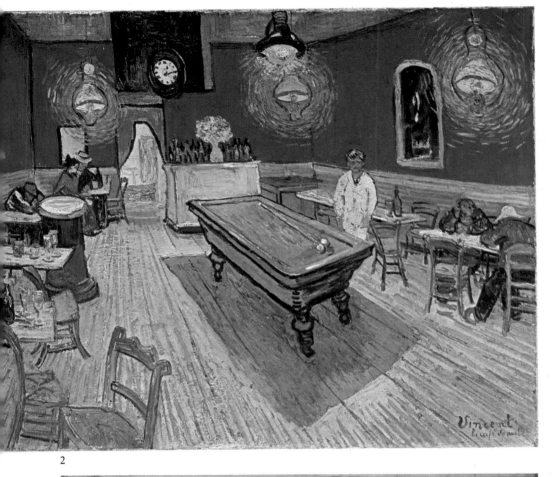

2

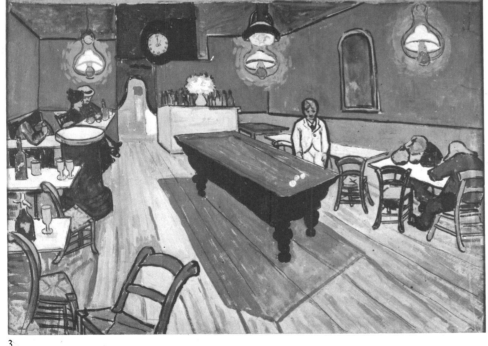

3

once set to work on a portrait of Dr. Rey and on the *Self-portrait with a Cut Ear*, in which he is seen, somewhat indifferent, with a fur cap on his bandaged head, smoking his pipe casually and looking like a Dutch sailor. He wrote cheerfully to his friend Koning: "My painter's equilibrium is not in the least upset."

But it was a precarious equilibrium. Roulin, who had stood by him in his misfortune and shown himself a true friend, was transferred to Marseilles, and Van Gogh felt his loss keenly. Before their departure Vincent painted the several portraits of Madame Roulin as *La Berceuse*. A relapse in early February took Van Gogh back to the hospital. Under Dr. Rey's care he soon was fit again; but during this time, because of a petition from some neighbors, his house was closed up by the police and Vincent had to seek new lodgings. Though greatly concerned about all this, Theo was about to be married and could not leave Paris, and hence sent Paul Signac to Arles instead. In March Signac spent a day there with Vincent, who went out and showed him the canvases still left in the "house of friends," where their dazzling colors stood out brilliantly against whitewashed walls. All his life Signac would retain a vivid memory of this astonishing encounter with Van Gogh the man and his paintings. His physical health improved, but Van Gogh fell prey to mental depression, and there seemed no way out to him. Theo left for Holland to get married, and Vincent wrote to him, urging that he transfer to his wife the affection he had always shown for his brother. He was painfully conscious of being a burden to Theo, whose remittances he so desperately needed, but he wanted at least to restore his brother's peace of mind. He thought of dis-

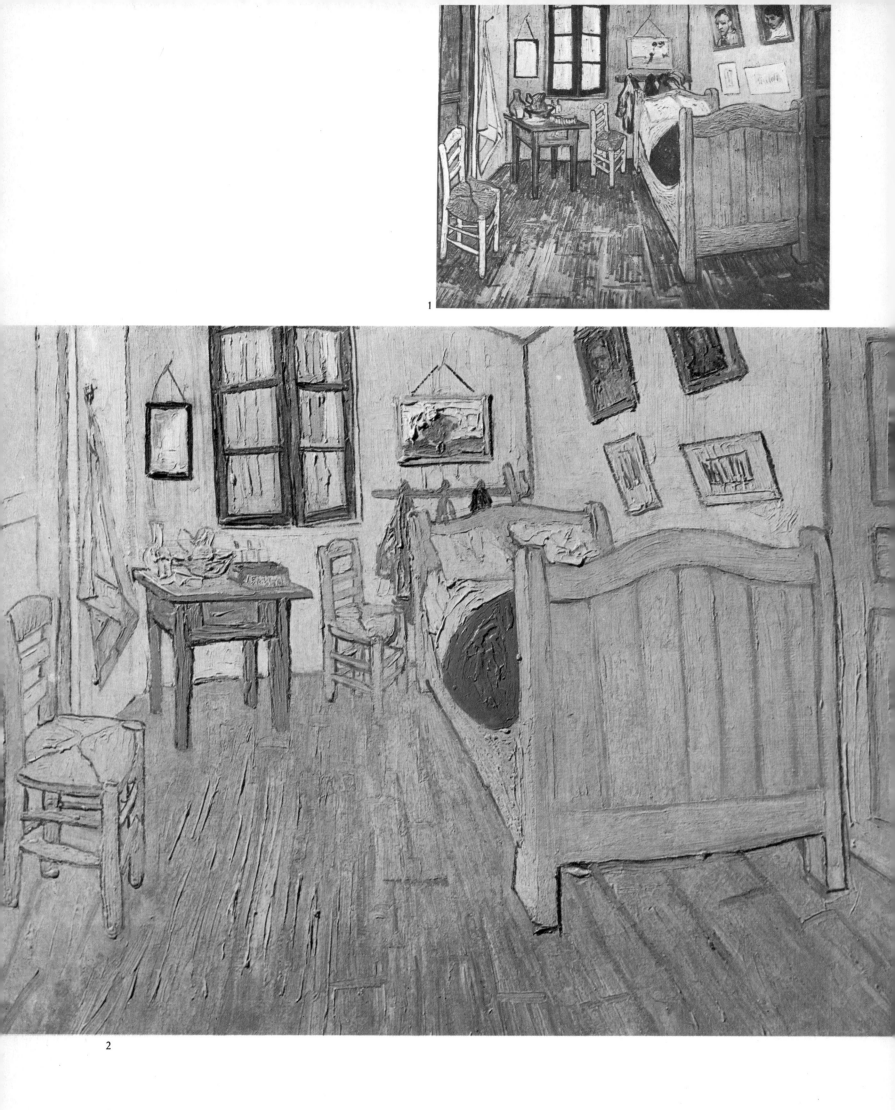

1

2

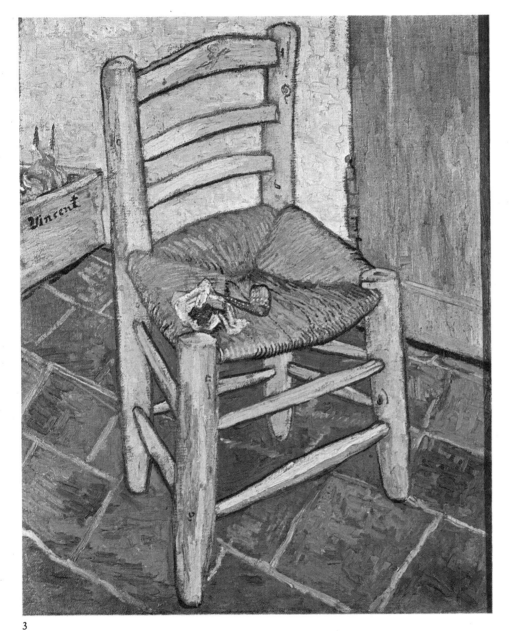

3

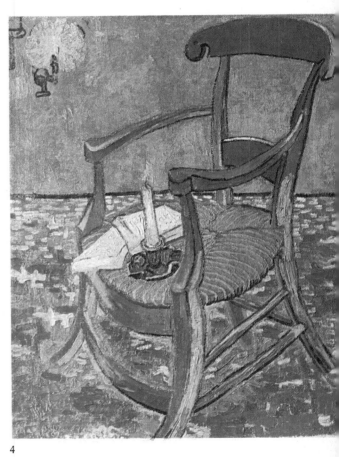

4

—not to speak of the spectacular whole of which it forms part—one wonders how his contemporaries, some of the better-informed among whom were not unaware of his existence, could remain blind to the appearance of such truly meteoric genius, one of the most brilliant in the history of painting. His lonely and alienated life, the harsh material

appearing, perhaps enlisting in the Foreign Legion, even of committing suicide. Finally, after consulting Dr. Rey, Van Gogh agreed to voluntary commitment to the nearby asylum of Saint-Rémy-de-Provence. On May 3, 1889, he was taken there by his friend Pastor Salles, and went without apprehension or rancor.
His stay in Arles, which lasted just over a year, had been marked by unpleasant events and personal conflicts, by stresses and shocks, by

broken friendships and even physical violence, all of which unsettled his mind. Yet this was the most fruitful period of his career. He now showed the full measure of his genius and carried his art to new heights. About two hundred paintings and some hundred drawings, these last perhaps even more striking in their perfection, represent the achievement of this first year in southern France. And before this homogeneous group of masterpieces

conditions he always had to endure, the moral and mental stresses he experienced, which very often cut him off from friends and a normal life—these are some possible explanations. Then, too, in taking inspiration from the humblest subjects and materials, his art was so unlike any other. At Arles his painting reached an intensity rarely, if ever, equalled before or after him. The time had not yet come, however, when pure painting would break

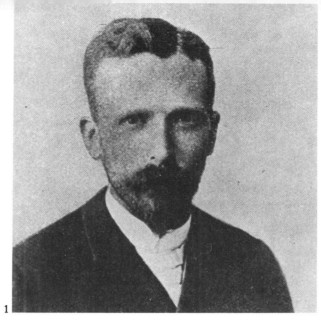

1

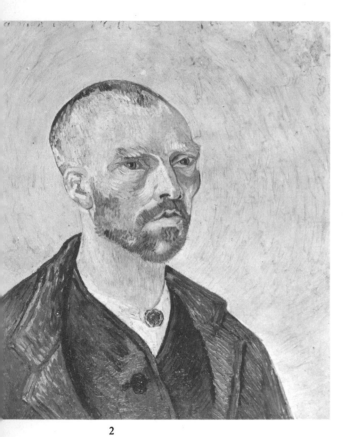

2

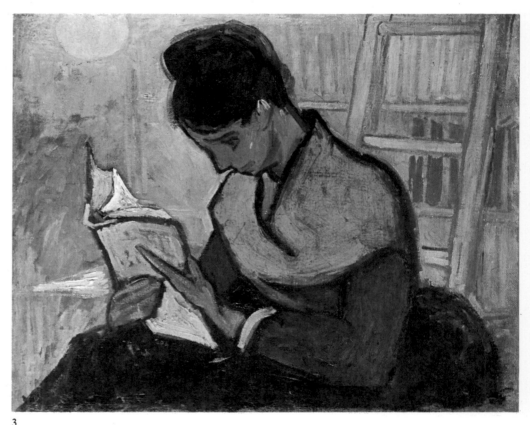

3

decidedly away from visual appearance and build a world of its own. Van Gogh remained dependent on the subject; but for him it was never a constraint—it was instead a stimulus. Through his insight into things and his grasp of their essence, he transformed the least element of reality, the most commonplace themes and people, into something of beauty and universal truth, of an emotional appeal that approached the sublime.

The first things he painted in Arles were the café tables at his boarding-house and the plain furniture in his room, the rustic bed, the deal chairs, the ordinary objects lying on the table. Though not much different from the things he had painted in Paris, these were treated differently now, as if to convey their very essence, whether by a touch of bright color or a thick black contour

line of instinctive, unerring sureness. When he depicts the bleak billiard room in the lurid glare of oil lamps, its dreariest accessories take on a supernatural life, just as outside in the night the small neighborhood houses and zinc-topped café tables glow strangely in the starlight. Color, in his eyes, was a jewel and a treasure, but it was also a natural emanation, to be handled without affectation or excess, allowing its innate significance to reveal itself. Nothing was further from Van Gogh's approach than the sometimes clumsy allusions of Symbolism or the schematic insistence on planes, surface divisions, or volumes practiced by others. His painting is the very embodiment of fluidity, and that is why it "bathes" the eye so naturally and wins the viewer's trust so spontaneously.

Still, it is obvious that certain ob-

jects painted by Van Gogh—some of them so repeatedly as to form recognizable sets of pictures—did have a symbolic meaning for him. The empty chairs are oppressive reminders of absence; the discarded, worn shoes evoke the eternal traveler; gypsy caravans, old coaches and farm wagons, or empty fishing boats drawn up on the deserted beach are subjects that seem almost obsessions for this searcher after the impossible. Some hope of salvation, an intimation of the absolute, was given to him by nature, by this southern landscape so different from anything he had known till then—its dry, hot and fiery character so resistant to frost or winter cold or death. The hundred or more landscapes Van Gogh painted in Provence have been grouped by Jean Leymarie in three main cycles: orchards, harvest crops, and gardens.

1 Theo van Gogh, photograph.

2 Self-Portrait. Arles, September 1888. Canvas, 24^1/$_2$ × 20^1/$_2$ in.
Cambridge, Mass., Courtesy of The Fogg Art Museum, Harvard University,
Maurice Wertheim Collection.

3 The Novel Reader. Arles, November 1888.
Canvas, 28^3/$_4$ × 36^1/$_4$ in. England, Private collection.

4 Portrait of Armand Roulin. Arles, November 1888.
Canvas, 26 × 21^1/$_4$ in. Essen, Folkwang Museum.

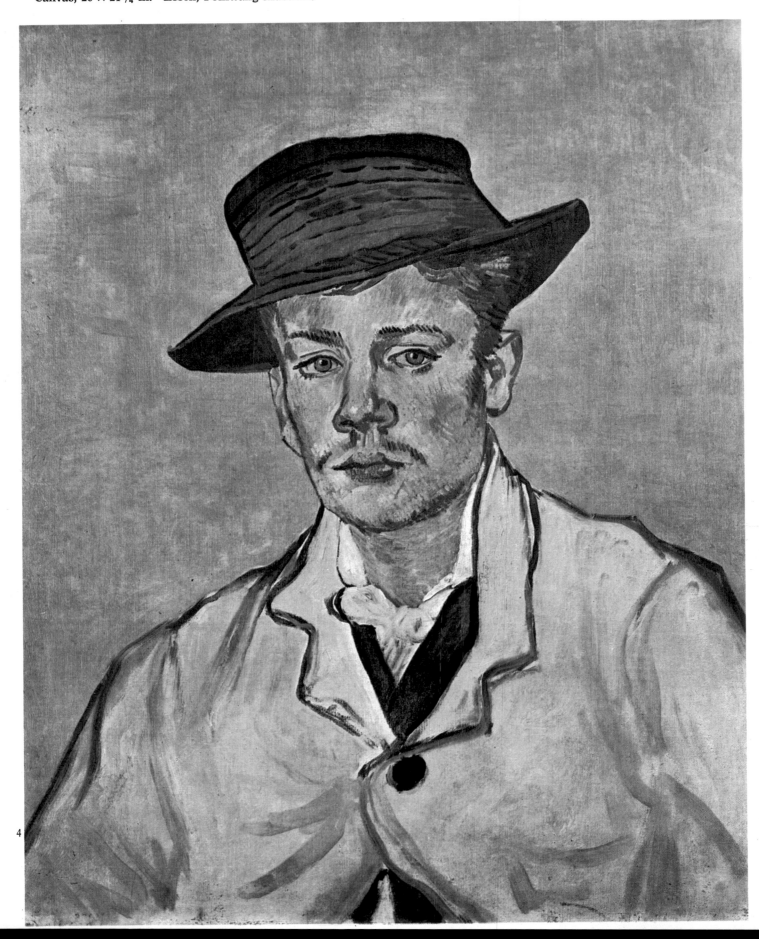

4

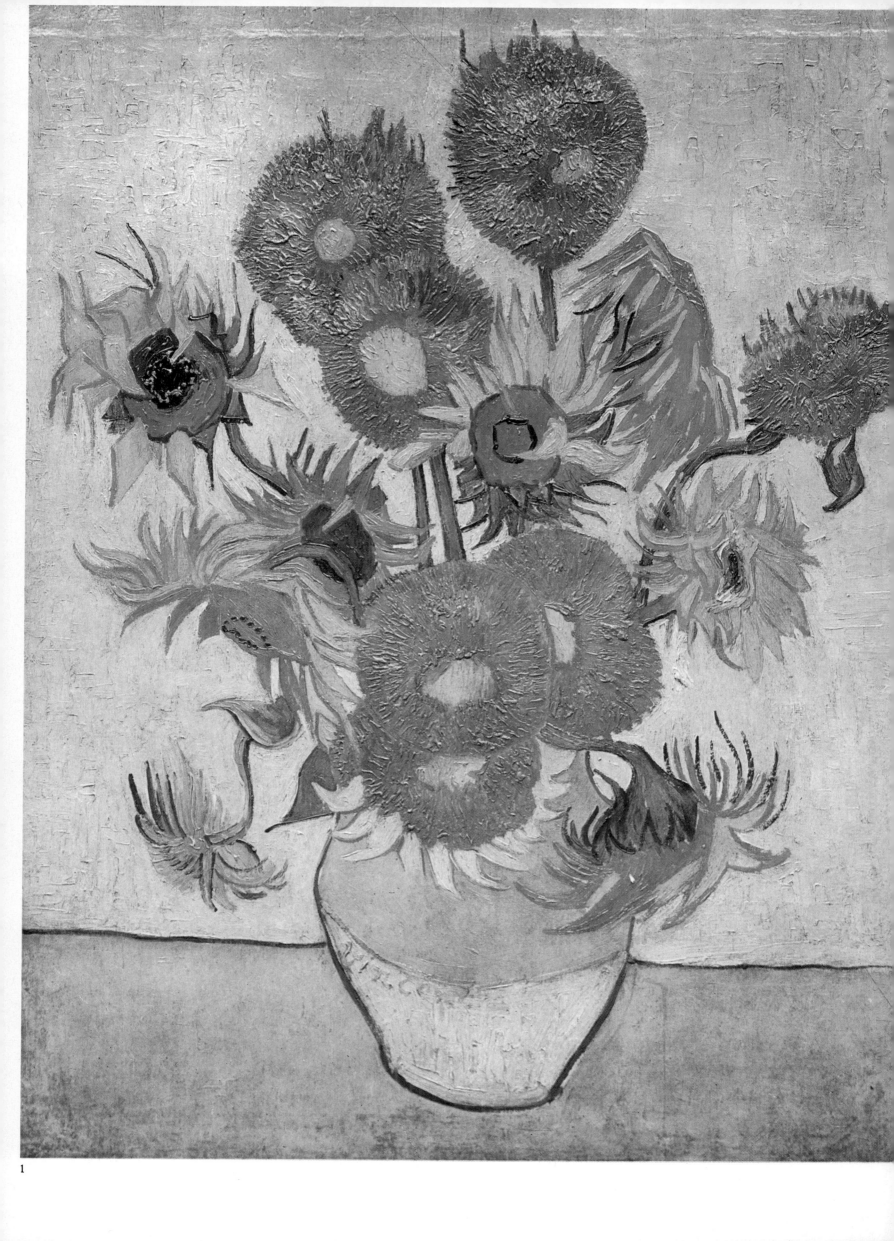

1

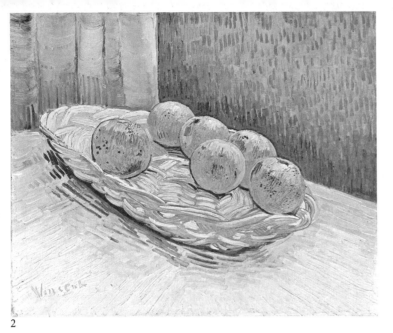

2

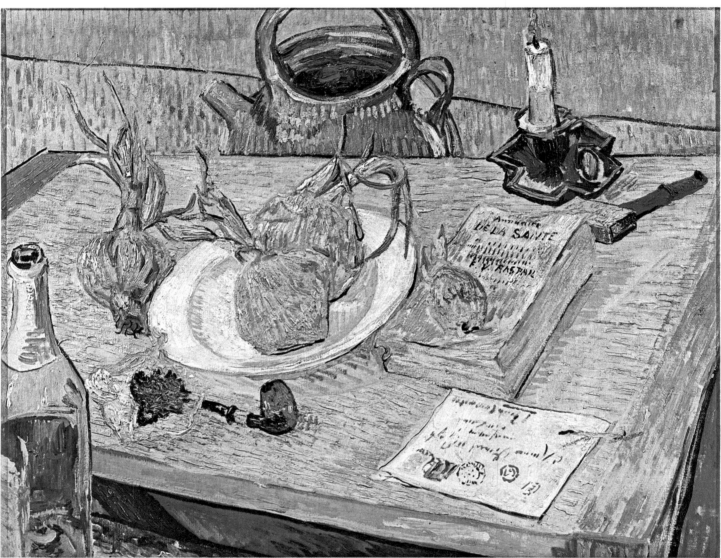

3

Some of these fall into regular sequences; others seem so closely related as to form polyptychs.

His first Provençal landscapes comprise a kind of survey of the natural features of the land and the impact of man on it—that is, crops, constructions, roads and paths, walls, all testifying to man's presence and the effects of his tools. Van Gogh's drawings, remarkable in their precision, show how carefully he went about this survey; with pen or reed (in imitation of Japanese art), he worked out what amounted to a landscape grid. He built up these drawings by the most elementary means: dots and short penstrokes, either juxtaposed or crisscrossed. Bunched up or spaced out in endlessly varied patterns that make the most of the blank areas of the white paper, these calligraphic marks convey to wonderful effect the spreading grainfields or the harvested plain, the course of the river, the branching of trees. In this virtuoso perfection, his drawings show that he had fully mastered his expressive means, and their quality equals that of his greatest paintings. Still, for him, these were only an intermediate stage, preparation for the achieve-

1 **Vase with Sunflowers. Arles, January 1889. Canvas, 37³/₈ × 28³/₄ in. Amsterdam, National Museum Vincent van Gogh.**

2 **Still Life with Oranges. Arles, March 1888. Canvas, 18 × 21¹/₂ in. New York, Goulandris Collection.**

3 **Still Life with Onions and Drawing Board. Arles, January 1889. Canvas, 19³/₄ × 25¹/₄ in. Otterlo, Kröller-Müller Stichting.**

1

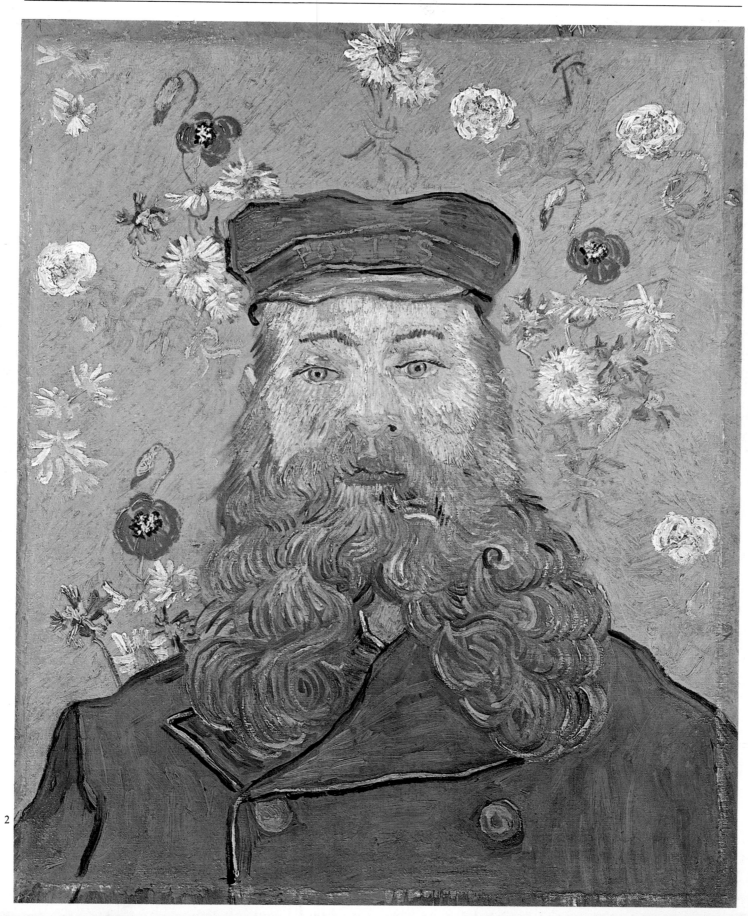

2

1 The Postman Joseph Roulin. Arles, August 1888.
Pen and ink drawing, 12³/₈ × 9¹/₂ in. Bern, Private collection.

2 The Postman Joseph Roulin. Arles, January-February 1889.
Canvas, 25⁵/₈ × 21¹/₄ in. Otterlo, Kröller-Müller Stichting.

3 "La Berceuse" (Portrait of Madame Augustine Roulin). Arles, January 1889.
Canvas, 36⁵/₈ × 29¹/₈ in. U.S.A., Private collection.

4 "La Berceuse" (Portrait of Madame Augustine Roulin). Arles, January 1889.
Canvas, 36¹/₄ × 28³/₄ in. Otterlo, Kröller-Müller Stichting.

later to do. He was neither the first nor the last to associate a given color with a certain emotion or mood, but his ideas on the subject were not simplistic. When he said of red and green that they are capable of expressing "those terrible things, human passions," he was thinking not of their visual appearance but of their underlying essence. He believed, as he put it, that "color in itself expresses something." The painter who understood this would thus speak directly to his fellow men. Van Gogh himself was that painter. Of all modern artists, he is perhaps the one who, since his

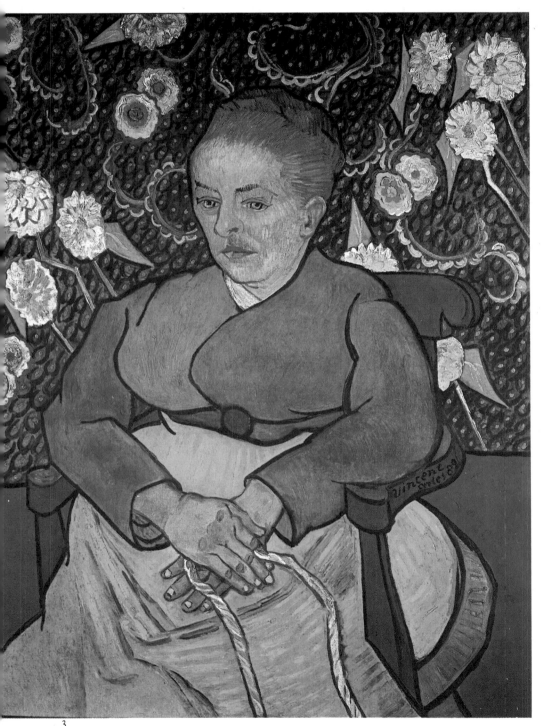

3

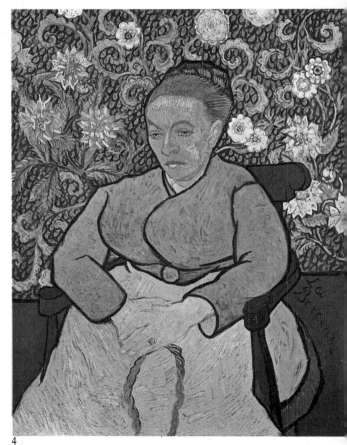

4

ment of which he dreamed, and which he was soon to realize: expression through pure color.

"The painter of the future," he wrote to his brother, "will be a colorist such as there has never yet been." He felt that each color was best suited to a particular mode of expression, and in this sense it may be said he used color like a language—but empirically, not systematically, as other painters were

death, has had the widest appeal and popular influence, though those who look at and admire his pictures perhaps do not always realize exactly what it is they derive from them.

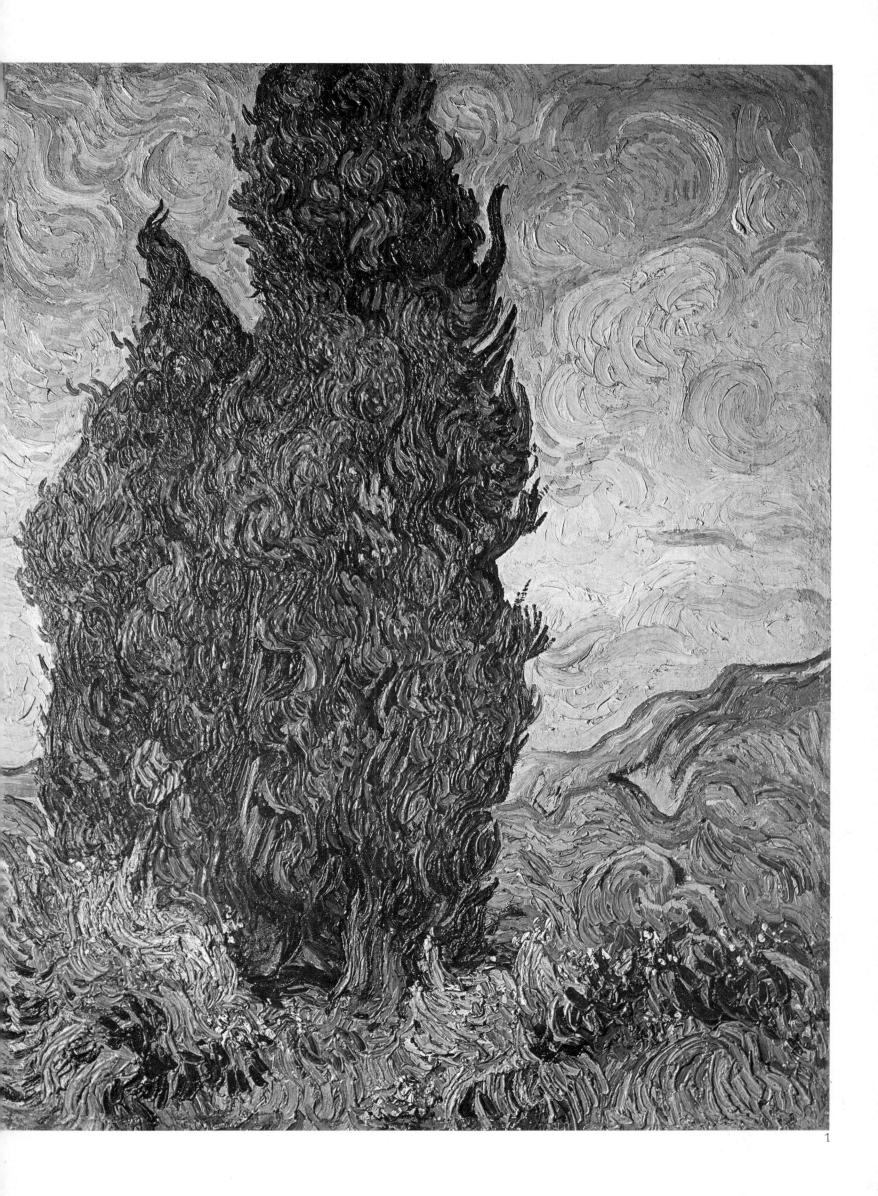

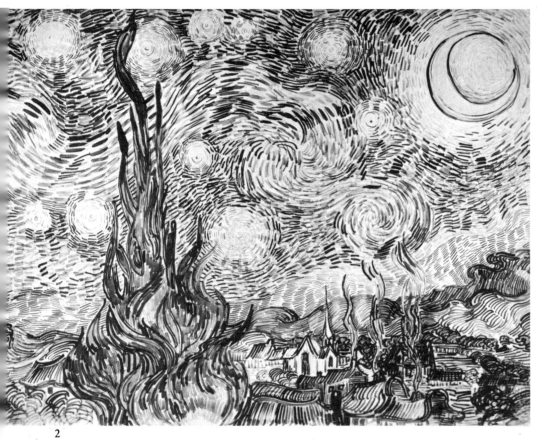

2

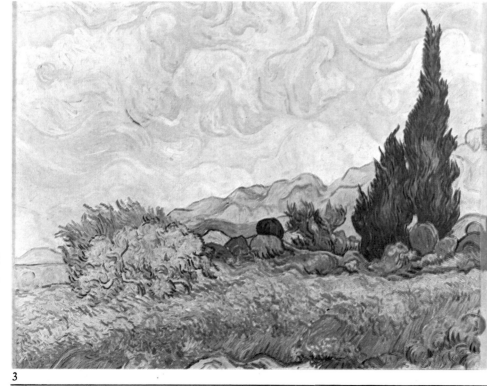

3

Van Gogh had a kind of dizzying perception of space. He filled the picture surface with a meticulous delineation of the elements he saw before him, always careful to link them together by roads or paths or fences. (Hence the importance for him of bridges, which are the focal point of so many of his landscape

4

views.) But far from flattening the picture surface, he scooped it out and reached into the farthest depths of space, linking all that was distant and static with his contorted, lyrical foregrounds where the eye pauses as if to find the horizon. He has drawn up a surprisingly thorough inventory of nature; by patiently unraveling the innumerable details that go to make it up and then achieving a most satisfactory synthesis of all those same elements, he opens our eyes and feeds our understanding. He was fond of a plunging sight line, which allowed him to unfold the full breadth of a landscape. His approach was often the same when he delineated ordinary objects standing in front of him; this is what gives his still lifes, never seen head-on, their unique vitality and movement. So emphasized and thus seemingly multiplied, his perspective

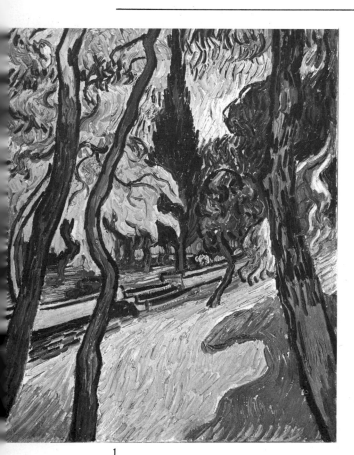

1

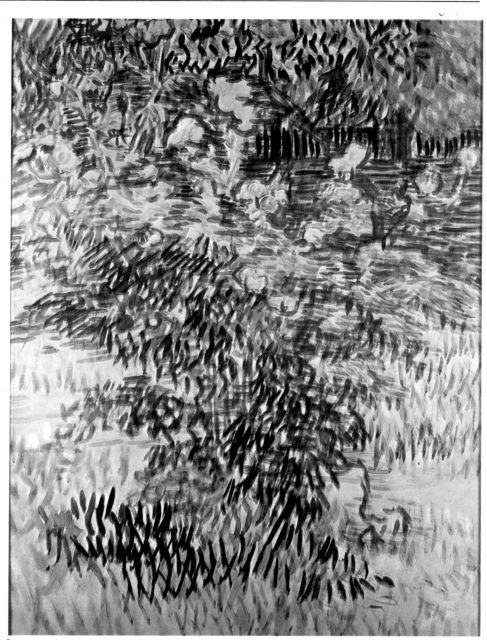

2

confers on everything he paints an implicit extension in space and time. Yellow is the key color of his Arles period, a sunny yellow that in interiors, the backgrounds of portraits, and the sunflower series veers toward intense shades of orange and a whole range of other hues brought out by the adjacent greens. In the famous pictures of sunflowers, revealing endless variations on these very ordinary plants—sometimes bunched together, sometimes in random disarray—the dominant yellow takes on all possible nuances. This was perhaps the moment when Van Gogh accomplished his aims most directly and simply, because the fire that burned within him, and would soon consume him, was now totally absorbed in a re-creation of nature. Gauguin's admirable portrait of Van Gogh done at Arles shows him paint-

ing his sunflowers; and it shows too that, despite the tragic clash between these two strong personalities, Gauguin thoroughly understood his friend Vincent.

On May 3, 1889, Van Gogh entered the asylum of Saint-Paul, just outside Saint-Rémy-de-Provence, about fifteen miles from Arles. This was housed in an old priory near the ancient Gallo-Roman site of Glanum,

opposite the hills called the Alpilles and the Baux cliffs. Though he enjoyed a certain freedom of movement and was treated with consideration owing to his friendship with Dr. Rey, it was after all a mental hospital and he had to share the life of its inmates. He accepted this condition with quiet resignation and adapted to an institutional routine that left him adequate time to paint.

58

3

And there was ample inspiration in the new motifs around him. He painted the pleasant park and garden around the hospital, with its benches and pond, and the surrounding olive trees and cypresses. He handled these themes with a certain detachment, and the resulting atmosphere is more like that of a peaceful summer residence than an asylum. His well-known canvas *The Prisoners' Walk*, set in a high-walled courtyard, may represent the haggard faces of the mental patients whose life he now shared, but it was directly inspired by a print by Gustave Doré from a series illustrating a book on London.

Van Gogh, then, did not find peace of mind at Saint-Rémy. Long periods of apathy were broken by fits of delirium which, as Jean Leymarie has pointed out, seem to follow a pattern coinciding with the events of Theo's life, the normal stages of a man's life which Vincent knew he himself would never experience—engagement, marriage, the birth of a child. What he suffered from was not a permanent derangement but

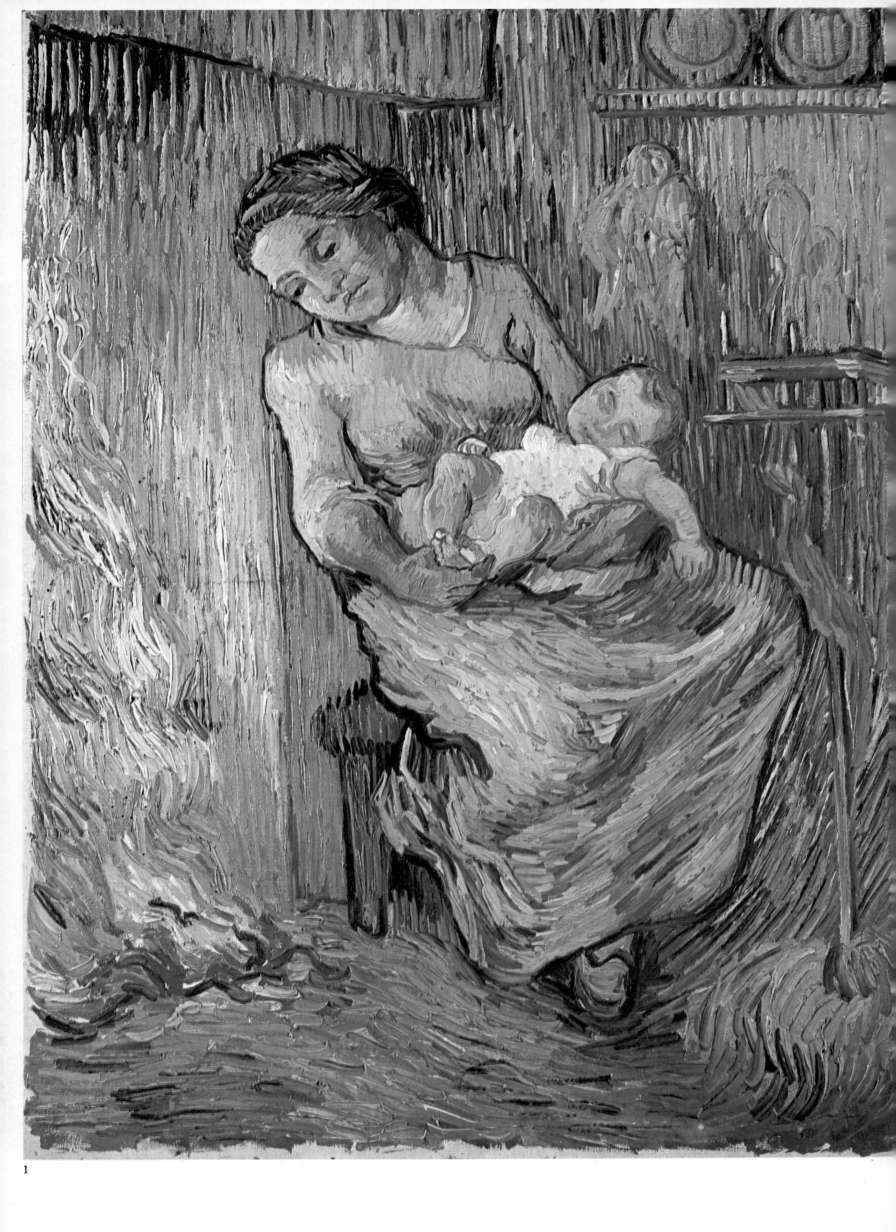

1

1 **Her Husband Is at Sea (after a reproduction of the picture
"L'homme est en mer" by Virginie Demont-Breton).
Saint-Rémy, October 1889. Canvas, 26 × 20¹/₃ in. Private collection.**

2 **"L'Arlésienne" (Portrait of Madame Ginoux),
after a drawing by Gauguin. Saint-Rémy, January-February 1890.
Canvas, 25⁵/₈ × 19¹/₄ in. Otterlo, Kröller-Müller Stichting.**

malaise, passing spells of mental unbalance or disorder that left him in despair. And during these crises, which various doctors and analysts have studied in retrospect, trying to detect symptoms of epilepsy or perhaps schizophrenia, Van Gogh was unable to paint. As soon as his mind cleared—and became, as it seemed to him, even more lucid than before—he regained full command of his artistic powers and set to work again. Nothing in his work betrays the signs of genuine madness, not even the *Self-portrait* of 1889, with its gaunt features as if wasted by his recurring breakdowns.

The one hundred and fifty paintings and one hundred drawings he did at Saint-Rémy show the continuing evolution of his art, even more striking than his progress at Arles. They have remarkable unity, for Van Gogh was now at the very heart of nature, less preoccupied with its colors than with its vital forms. His meadows and wheatfields are swept up in broad movements, and to the vertical cypresses punctuating the landscape are added olive trees with gnarled trunks, whose strangely mobile volumes seem to surge through a space closed off by cubically tiered rocks. His vision had been enlarged, and when these great panoramas took the form of night pieces, such as his favorite *Starry Night*, the swirling shapes of trees seem to reach out to the very heavens in a rhythmic pattern of dark greens and yellows. So pantheistic in inspiration, these works are more boldly imaginative than any of his previous landscapes. Since he was often confined to his room at Saint-Rémy, he may thus have projected his thoughts freely into themes he had totally mastered and could paint indoors, so distinct were they in his mind's eye. He disregarded the lesser details he had once observed and lingered over, to

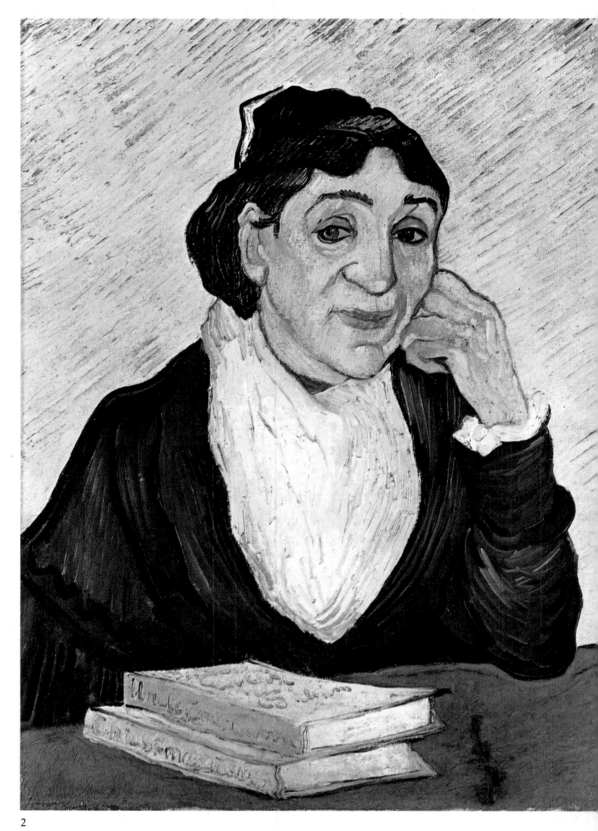

2

1 **Cypresses with Two Female Figures.** Saint-Rémy, June 1889.
Drawing in black chalk, pen, reed, and India ink, $12^{1}/_{4} \times 9$ in.
Otterlo, Kröller-Müller Stichting.

2 **Cypresses.** Saint-Rémy, June 1889.
Drawing in pen, reed, and ink over pencil, $24^{5}/_{8} \times 18^{1}/_{4}$ in.
Chicago, Courtesy of The Art Institute of Chicago, Gift of Robert Allerton.

3 **Cypresses with Two Female Figures.** Saint-Rémy, June 1889–February 1890.
Canvas, $36^{1}/_{4} \times 28^{3}/_{4}$ in. Otterlo, Kröller-Müller Stichting.

4 **Horse and Cart.** Saint-Rémy, 1890. Pencil and black chalk drawing,
$8^{1}/_{2} \times 18^{1}/_{2}$ in. Amsterdam, National Museum Vincent van Gogh.

5 **Road with Cypress and Stars.** Saint-Rémy, May 1890.
Canvas, $35^{7}/_{8} \times 28$ in. Otterlo, Kröller-Müller Stichting.

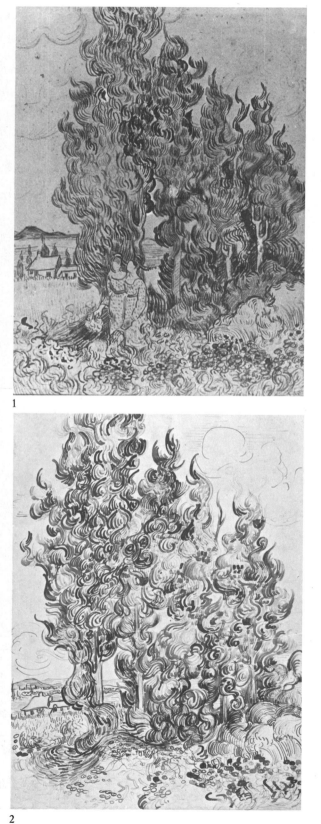

1

2

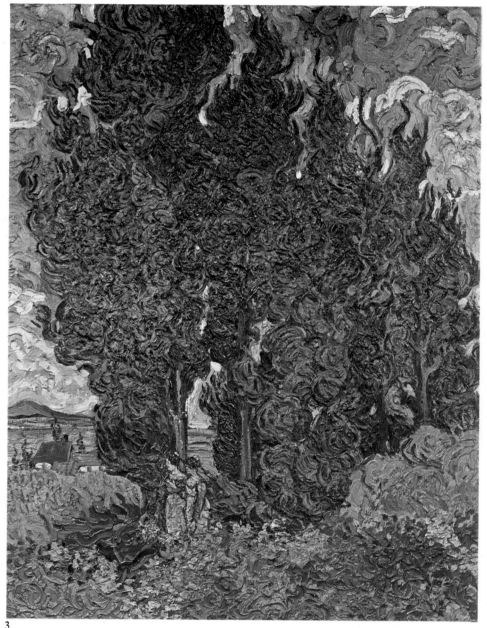

3

bring out the essential turbulent rhythms he now felt in his own breast. It was like an irresistible release of pent-up forces within him. There were also quiet, reflective moments when he lovingly painted a flowering almond branch or the grass and insects in the park. He began reading again, Shakespeare in particular; he ordered books and prints and spent hours absorbed in them. He again made free copies after Millet, and also of Rembrandt and Delacroix, some of them religious themes. His thoughts reverted to his old spiritual concerns, and the problem of death began to obsess him. Following a picture of the dead Christ, he painted the raising of Lazarus. It was, it seemed, his own life at stake.

4

5

4 - VAN GOGH AND DEATH

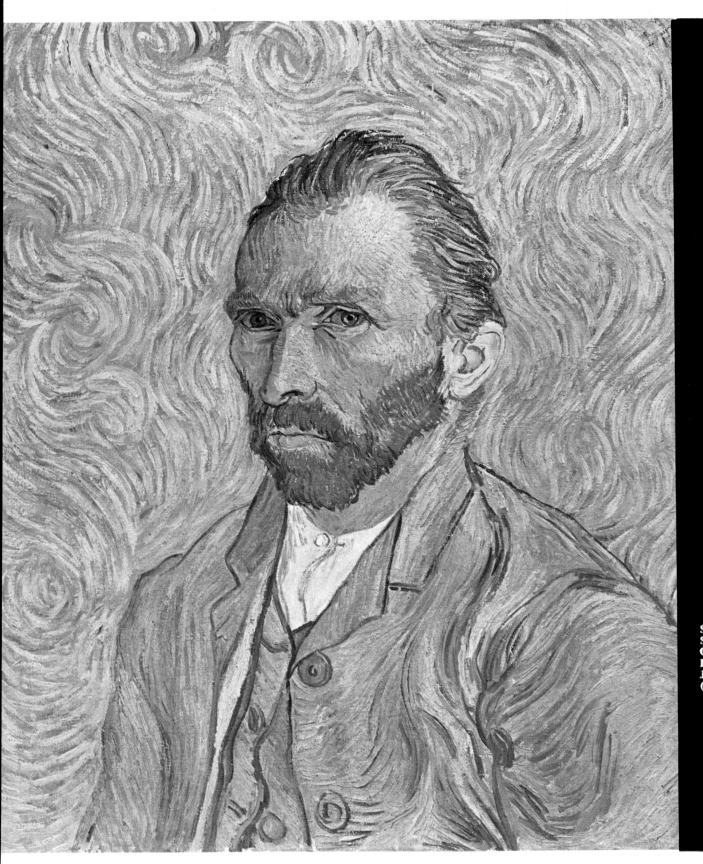

**Self-Portrait.
Saint-Rémy, 1889–1890.
Canvas, 25⁵/₈ × 21¹/₄ in.
Paris, Musée du Louvre,
Jeu de Paume.
(Photo AGRACI)**

1

2

During his brief lifetime, Van Gogh was never to find peace. The asylum he voluntarily entered failed to give him the protection he sought, and the treatment he received was of little avail. Like an exile in a happier land, he remained a self-tormented outsider. His year's stay at Saint-Rémy ended in a deepening sense of anguish. Worried by the reports he received about Vincent, Theo brought him back to Paris, without realizing the traumatic effect his own happy home life, now graced by a young wife and a baby boy (christened Vincent), might have on his brother's mind.

Vincent arrived in Paris on May 17, 1890. He had lost weight at Saint-Rémy, and his thinness emphasized the breadth of his shoulders. Moreover, his difficult personality reaffirmed itself. Theo met him at the station, took him at once to his new apartment in Montmartre, at 8 Cité Pigalle, and introduced him to his wife and child. This first contact was simple and affectionate, almost as if he had entered a home of his own, for his pictures lined the walls

and were strewn about on the furniture. As he gazed at this fabulous collection of his own work, particularly the brilliant canvases he had just sent up from the Midi, Vincent could measure the distance he had covered. Despite his doubts and misgivings, he was plainly conscious of his achievement; besides, there were signs it was being recognized elsewhere. Albert Aurier had just published in *Mercure de France* the first article devoted to Van Gogh and his work. Old friends came to see him: Père Tanguy, Guillaumin, Pissarro, and perhaps Lautrec. But after his cloistered life at Saint-Rémy, the noise and bustle of the city wore on him. Having spent only four days in Paris, he went to Auvers-sur-Oise, about an hour from the city, where Theo arranged for him to be treated by Dr. Paul-Ferdinand Gachet. A personal friend of Pissarro and of Cézanne, Dr. Gachet was himself an amateur painter and a discerning collector. It was he who taught Van Gogh the etching technique. The two men took to each other quickly. The perceptive Gachet, who appreciated Van Gogh both as a man and as a gifted artist, encouraged him to get back to work, sure this would be the best therapy. Van Gogh took room and board at the Café Ravoux on Place de la Mairie. He lost no time in setting to work again. He called regularly on Dr. Gachet, who practiced in Paris but spent his weekends at Auvers in a rambling countryhouse where he kept his art collection. At various times Cézanne, Pissarro, and Guillaumin all stayed and also worked there. In one room the doctor had installed an etching press, used by both Cézanne and Van Gogh.

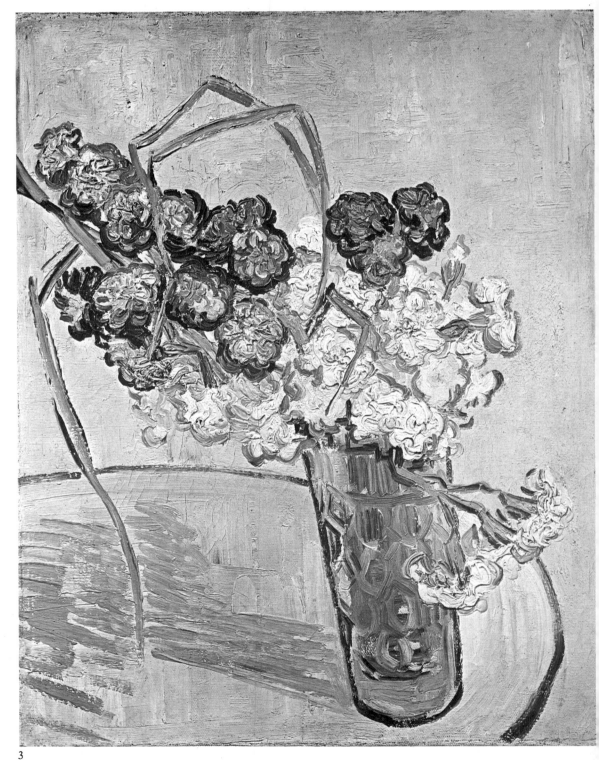

3

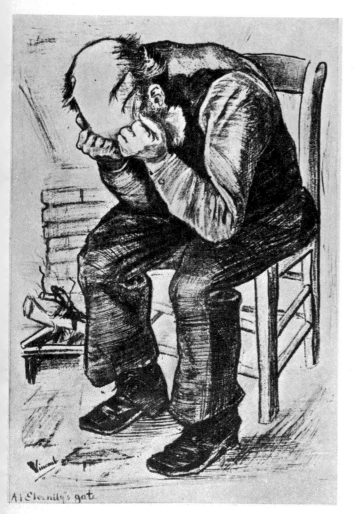

1

Vincent began a portrait of him, and in the course of the sittings their friendship ripened. Dr. Gachet invited Vincent to dinner and permitted him to work in his house and extensive park, with its terraces overlooking the Oise Valley.

Auvers, a quiet town in the Valmondois region, is built on a slope above the Oise River and is surrounded by orchards and wheatfields. Charles Daubigny had a studio there in the 1860s and 1870s, and Daumier died nearby in 1879. Van Gogh had been among the first to appreciate the paintings of Daumier, then best-known for his work as a caricaturist; also, one of the last pictures

the Dutch artist painted at Auvers was *Daubigny's Garden*, of which he made several drawings and sketches as well. There were not many customers at the Café Ravoux, so Van Gogh was allowed to set up a make-shift studio back of the restaurant. He painted the broad expanse of landscape around the town, its checkered fields dotted with small houses and marked off by country lanes, enlivened by an occasional cart or buggy. He found fresh inspiration in the steeply pitched thatch roofs of the cottages in the neighboring hamlet of Chaponval, and above all in the vast wheatfields undulating across the plateau and in the great flights of crows hovering overhead as the harvest approached. The few portraits which he did at Auvers, particularly that of Dr. Gachet, are marked by the same dominant rhythms that surge through his landscapes. His vision of nature was becoming more and more agitated and dramatic, in foreshadowing the tragic events now at hand.

The circumstances of Van Gogh's death were more like Greek tragedy than Christian narrative (though he had been brought up on the Bible and read it continually). We find the same relentless chain of events, the same inevitable and necessary end, the same submissiveness to fate. On June 8, 1890, Dr. Gachet invited Theo, with his wife and baby, to come to Auvers. The day they all spent together was a joyful occasion for Vincent. He gave his nephew one of the bird's nests he

had collected as a youth and had kept as a talisman. He spoke eagerly of his dream that they might all be able to live together in a country-house, and Theo seemed to share that hope.

But Theo, at this very time, was in poor health (with bronchitis and chronic nephritis) and was having financial difficulties. His position at Goupil—Boussod and Valadon, that is—which had enabled him to support his family and his brother, had become precarious owing to the risks he had taken by supporting the Impressionist painters, particularly Gauguin. His employers were

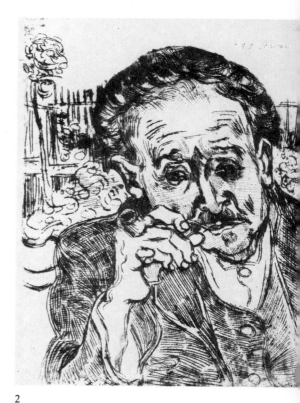

2

1 **At Eternity's Gate. The Hague, late November 1882.**
 (Van Gogh treated the same subject in a canvas painted at Saint-Rémy in May 1890.) Lithograph, 21⁷/₈ × 14³/₈ in. New York, Private collection.

2 **Portrait of Dr. Gachet. Auvers-sur-Oise, May 25, 1890.**
 Etching, 7¹/₈ × 5⁷/₈ in. Bremen, Kunsthalle. (Photo Stickelmann)

3 **Portrait of Dr. Gachet. Auvers-sur-Oise, early June 1890.**
 Canvas, 26³/₄ × 22¹/₂ in. Paris, Musée du Louvre, Jeu de Paume. (Photo Josse)

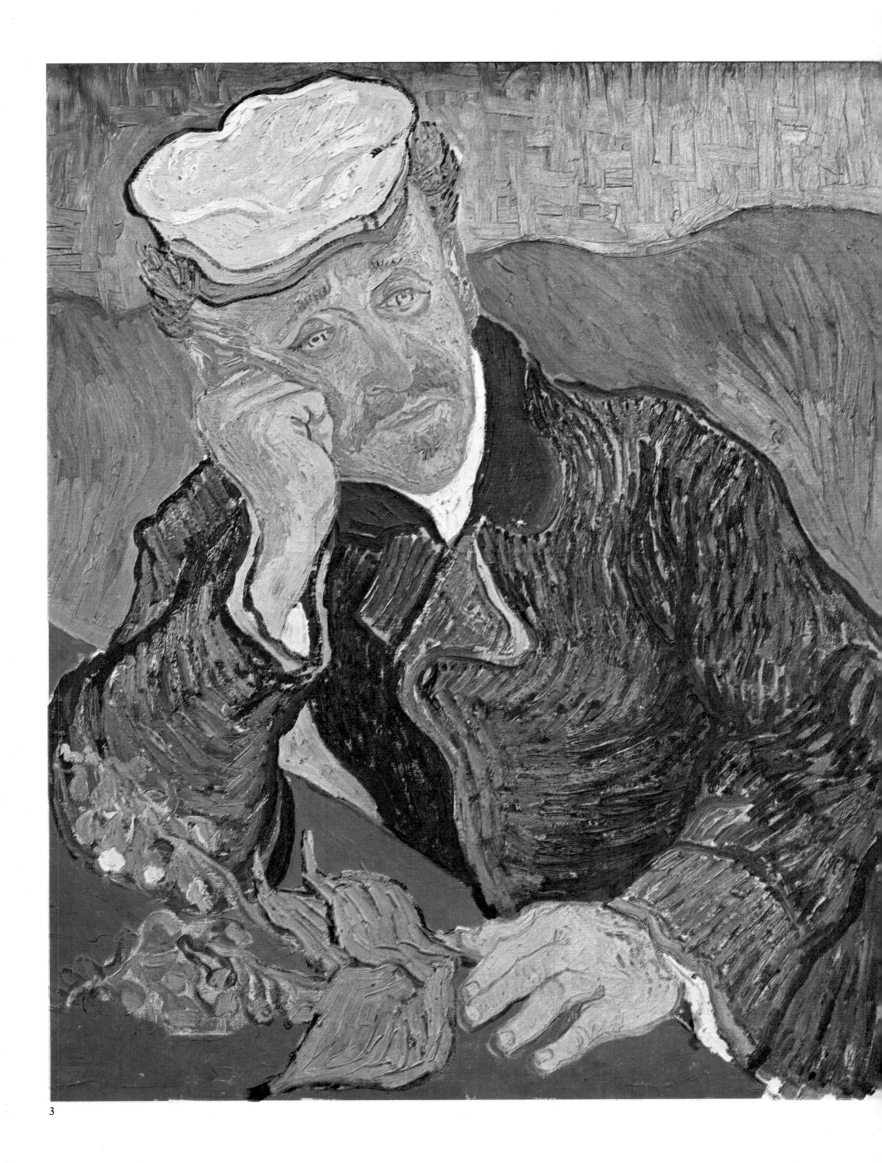

3

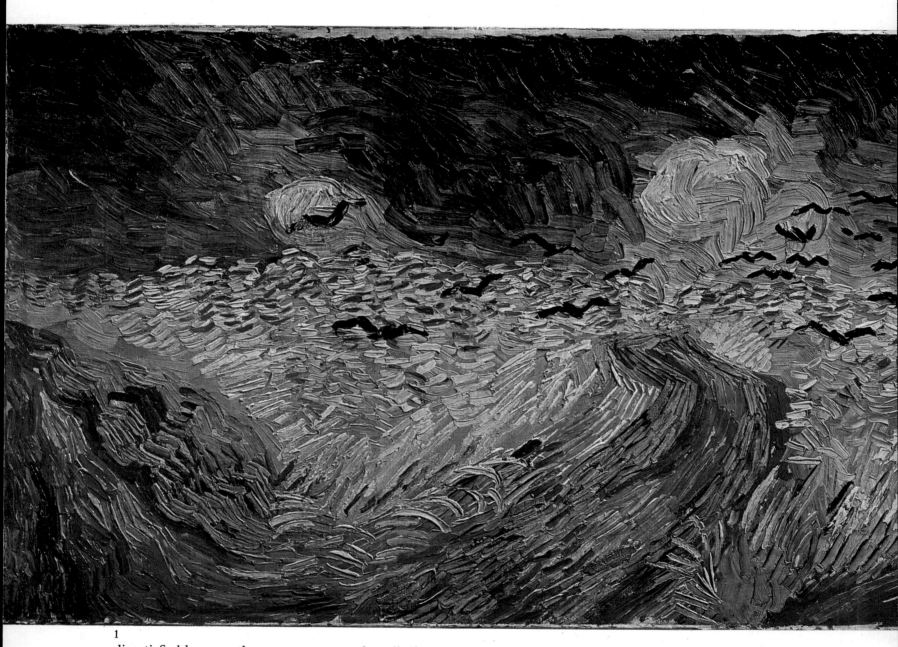

1

dissatisfied because there was as yet no demand for works by these artists. Theo also wished to establish a gallery of his own but lacked the necessary capital. His regular remittances to his brother were now late; then little Vincent became seriously ill, disrupting another expected visit to Auvers. So, on Sunday, July 6, 1890, Uncle Vincent himself came to Paris. The day ended with a rather heated discussion between Vincent and his brother or sister-in-

law (it is not certain which), and he left abruptly for Auvers. Earlier that day he had lunched with Lautrec and met the critic Albert Aurier, who took him home and introduced him to several friends. One of these was Julien Leclercq, friend, model, and biographer of Lautrec, who described Van Gogh as he saw him that day: "Nervous, bright-eyed, with a high forehead, chilly in manner, he reminded one vaguely of Spinoza, concealing beneath a timid exterior

an impassioned mental activity."
After Vincent left for Auvers again, Theo decided to take his wife and child back to Holland and gave up plans for spending a holiday with his brother. Disturbed by Theo's imminent departure, fearing that his indispensable remittances might be cut off, and irritated by the disorderly pile in which he had found his pictures in Père Tanguy's storeroom, Vincent felt as if everything were crumbling around him. Further an-

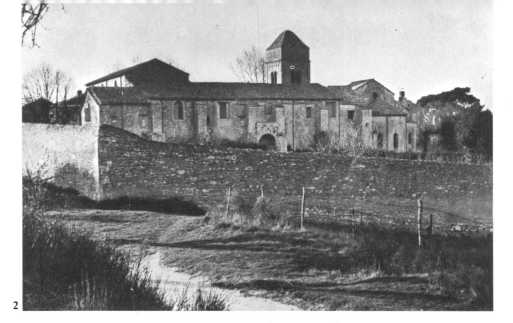

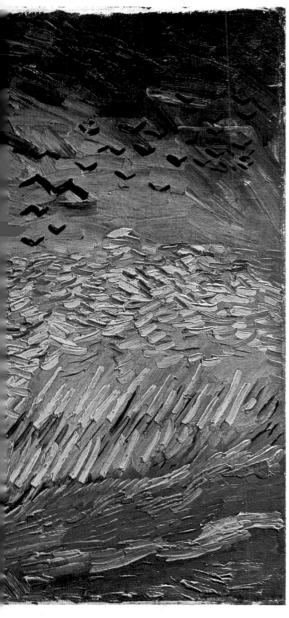

now that he painted his three great *Wheatfields*, pouring all his emotions of the moment into this moving expression of "sadness and extreme loneliness."

On July 23 he wrote his last letter to Theo and spoke of the uselessness of life. On Sunday, July 27, he went out into the familiar fields, not with his painter's gear but with a revolver to shoot crows. There, in this landscape which had inspired his most direct and intense emotional expressions, and from which he had extracted the essence, he tried to shoot himself in the heart, but the bullet went wide of the mark. Concealing his wound, he had just enough strength to get back to his room.

Surprised at not seeing him come down for supper, the Ravoux's went up to him and, seeing blood on his coat, realized what had probably happened and sent for Dr. Gachet. The doctor found that the bullet was lodged so that it could not be extracted. He asked for Theo's address, but Vincent refused to answer. So Theo was not notified until he arrived at his gallery on Monday morning. He came at once and he found Vincent calmly smoking his pipe in bed. All day long the two brothers talked together in Dutch, and that night Theo lay down on the bed beside Vincent, who was heard to murmur, "I want to go away." He died at 1:30 A.M. on July 29, 1890.

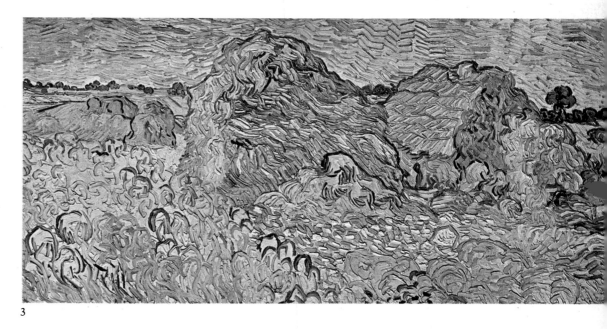

noyance came when Dr. Gachet, called away by a patient, missed an appointment with him; he convinced himself the nervous and restless doctor was as sick as he himself and could be of little help.

On July 14, the national holiday, he hoped for a visit from his brother, but Theo did not appear and Vincent spent a sad, lonely day. Theo's approaching departure for Holland struck him as an ominous sign. He kept working, however, and it was

1 **Wheatfield with Crows. Auvers-sur-Oise, before June 9, 1890.**
Canvas, 19⁷/₈ × 39⁵/₈ in. Amsterdam, National Museum Vincent van Gogh.

2 **Asylum of Saint-Paul-de-Mausole at Saint-Rémy, photograph.**
(Photo Van Rhyn-Viollet)

3 **Wheat Stacks. Auvers-sur-Oise, July 1890.**
Canvas, 19⁵/₈ × 39³/₈ in. Winterthur, Private collection.

DOCUMENTATION

THE IDEAS OF VAN GOGH

Van Gogh's letters have provided material for countless interpretations of his personality. They have been drawn upon by his biographers and combed by analysts in search of signs and causes of his mental instability. His letters record many specific facts and happenings—the exact time of a visit, the date of arrival in a particular place—and tell us about the books he read and the pictures he was working on; but in them, consciously or unconsciously, he says little that is revealing about any episodes in his intimate life. For all their evident sincerity and spontaneity, it should not be forgotten that most of these letters were written to a much younger brother (Vincent was nineteen and Theo only fifteen when their correspondence began), who at first was not so much a confidant as an admiring disciple. Later these roles were reversed; Theo having become his benefactor, Vincent was placed in a position of inferiority and even guilt with respect to a brother who continued to support him even when he had urgent family needs of his own. Beginning in particular with the Arles period, when Theo got married, Vincent became prey to feelings of remorse and frustration for the burden he imposed on his brother. Gauguin, five years his senior, aroused feelings of admiration and respect—in general, submission, but sometimes also a flash of rebellion. Vincent felt freer in his dealings with Émile Bernard, who, as a friend and ally of Gauguin, remained a mediator for him with the authoritarian master of Pont-Aven. Furthermore, Van Gogh seems never to have had any real intimacy with his mother, and his sister Wilhelmien was too young to be taken into his confidence.

The man revealed in this torrent of letters will therefore long continue to nourish the interest and curiosity of psychologists intent on studying an ardent, passionate personality with so elusive an essence. It may be of interest here to sample this correspondence and see what Van Gogh himself wrote about his work as a painter. His discerning judgments and insights seem the more remarkable in view of the physical and mental stress he was so often under, and affirm how certain he was that, though as yet unrecognized, he was doing something that would have significance for the future. And he was right, for his work heralded some of the greatest innovations in twentieth-century art and profoundly influenced many of its strongest personalities. In his early years of apprenticeship and spiritual search, his painting was still imbued with missionary zeal. It was somber and heavy, emphasizing the hardships and sadness of working-class and peasant life; it kept within a certain naturalist tradition of social concern. Nevertheless, he had already achieved an intensity of expression and a powerful simplification that set him

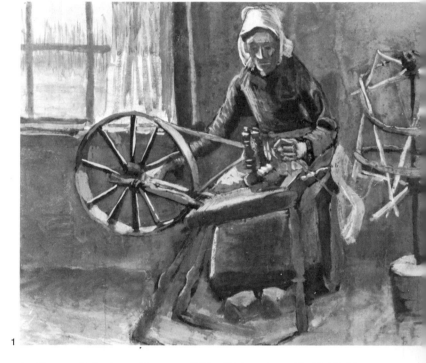

1 Woman Spinning. Nuenen, 1884. Watercolor with highlights in white lead, 13 × 16^1/$_8$ in. U.S.A., Private collection.

2 Le Moulin de la Galette. Paris, early winter 1886–1887. Canvas, 21^5/$_8$ × 15^1/$_8$ in. U.S.A., Private collection.

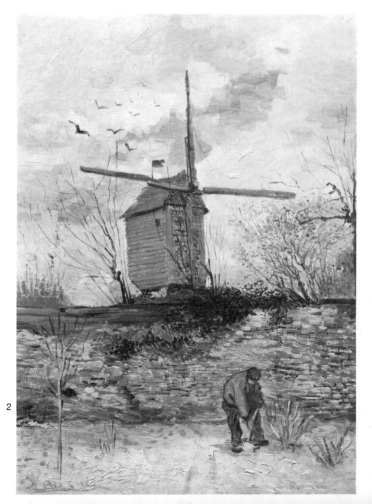

apart both from the academic tendencies of his day and from other contemporaries in a naturalistic vein. From 1886 on, when his arrival in Paris worked a fundamental change in his artistic vision and his whole conception of life, his letters become more interesting, for he was now beginning to discover himself. Writing (in English) to his friend H. M. Levens, an English artist he had become acquainted with in Antwerp, he said:

"The French air clears the brain and does good—a world of good. I have been in Cormon's studio for three or four months, but I did not find it so useful as I had expected it to be. It may be my fault, however; anyhow I left there too as I left Antwerp, and since I [have] worked alone, and fancy that since I feel my own self more."

In his first letter to Émile Bernard, written in Paris in the summer of 1887, he said:

"I persist in believing you will discover that in the studios one not only does not learn much about painting, but not even much good about the art of living; and that one finds himself forced to learn how to live in the same way he must learn to paint, without having recourse to the old tricks and eye-deceiving devices of intriguers."

In Paris he saw the work of the Impressionists and became friendly with the younger painters who were seeking to enrich and extend the basic Impressionist departures: namely, Seurat, Signac, Anquetin, Gauguin, Bernard, and Lautrec. At this point his own palette brightened considerably. From Paris, in late 1887, he wrote to Levens (again in English):

"In Antwerp I did not even know what the Impressionists were; now I have seen them, and though *not* being one of the club, yet I have much admired certain Impressionists' pictures."

"And now for what regards what I myself have been doing. ... I have made a series of color studies in painting, simply flowers, red poppies, blue corn-flowers and myosotis, white and rose roses, yellow chrysanthemums—seeking oppositions of blue with orange, red and green, yellow and violet, seeking broken and neutral tones to harmonize brutal extremes. Trying to render intense color and not a gray harmony."

"Since I saw the Impressionists I assure you that neither your color nor mine as it is developing ... is *exactly* the same as their theories. ... I did a dozen landscapes too, frankly green, frankly blue."

He admired the Impressionists, but with a discerning judgment that included some lingering reservations:

"You hear about the Impressionists and form a high opinion of them in advance. Then the first time you

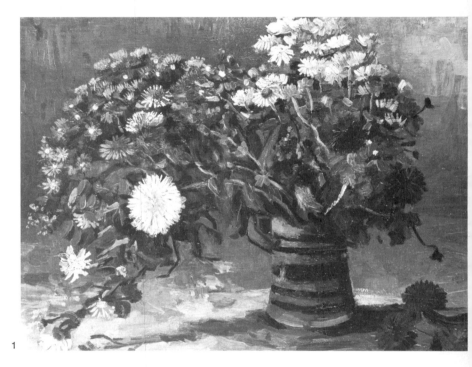

see them you are bitterly disappointed, you find it slipshod, ugly, ill-painted, ill-drawn, bad in color, quite wretched. That was in fact my own impression when I first arrived in Paris."

These same artists gave him, nonetheless, the valuable example of a productive work discipline. From Paris, in the summer or fall of 1887, he wrote to his sister Wilhelmien:

"I have had the opportunity to study the question of colors.... Last year I painted hardly anything

but flowers, to get into the habit of using some other color than gray—such colors, that is, as pink, pale or raw green, light blue, violet, yellow, orange, a nice red. This summer, while painting landscapes at Asnières, I saw more colors there than before."

A year later he discovered in Provence "the land of rose-laurels and a sun like sulfur." In March 1888, a few days after his arrival in Arles, he wrote to Émile Bernard:

"This country seems to me as beautiful as Japan in its limpid atmosphere and gay color effects. Water forms patches of beautiful emerald or rich blue in the landscape, just as one sees in Japanese prints. The sunsets have a pale orange hue that makes the fields appear blue. The sun, a splendid yellow."

His frequent allusions to Japan testify to the influence exerted not only on Van Gogh but on many painters of that period by Japanese prints, just then being discovered in the West. Van Gogh had already seen and bought some in Belgium, but in Paris they could be had for a few pennies apiece at the Bing Gallery in Rue de Provence, which had a stock of over a hundred thousand Japanese prints. Most painters did not attempt to imitate this exotic art but incorporated certain of its traits into their personal experiments. Japanese influence, along with other contemporary trends, thus became one of the formative elements of the new art. For Van Gogh, it confirmed the direct observations he had made from nature:

"All my work is based to some extent on 'Japonaiserie' ... Japanese art, in decline in its own country, takes root again in the French Impressionist artists. ... Now isn't it almost a religion, what we learn from these Japanese, who are so simple and who live within nature as if they themselves were flowers? One can hardly study Japanese art, it seems to me, without becoming more cheerful and happy, and we need to go back to nature in spite of our education and our work in a conventional world."

To his sister, he wrote:

"Theo wrote to me that he had given you Japanese pictures. This is surely the most practical way to arrive at an understanding of the direction which painting in bright colors has taken at present. For my part, I don't need Japanese pictures here, for I am always telling myself *that here I am in Japan.* Which means that I have only to open my eyes and paint what is right before me, if it strikes me so."

At Arles he read Pierre Loti's novel of Japanese manners, *Madame Chrysanthème,* and was greatly affected by it. In writing to his sister about his painting, he referred to some of the oddities he had learned about Japan from Loti's book:

1

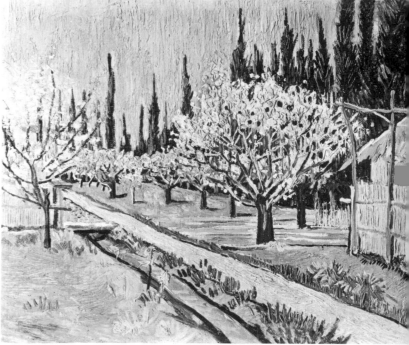

2

"You know, the Japanese have an instinctive urge for contrasts and eat sugared peppers and salted sweets. ..."

In Arles Van Gogh painted feverishly, under the blazing sun, directly from nature, abandoning a particular study as soon as a wheatfield was harvested or as soon as a bouquet of flowers began to wilt. Fascinated now by color, he spoke of it again and again in his letters:

"What Pissarro says is true, we should boldly exaggerate the effects produced by the harmony or discord of colors. It is the same for drawing the right line, the right color, is this not perhaps the

essential thing to aim for, since the reflection of reality in a mirror, if it were possible to record it with color and all, would not be a painting, no more than a photograph would."

While respecting the laws of color, he investigated on his own as well and asked himself questions about it. For instance, to Bernard he wrote:

"A technical question. Just give me your opinion on it in your next letter. I am going to put *black* and *white* boldly on my palette and use them just as they are. When—and note that I am speaking of color simplification in the Japanese manner—when in a green park with pink paths I see a gentleman dressed in black, who is reading *L'Intransigeant*... over him and the park, a sky of ordinary cobalt blue. Then why not paint [him] with ordinary bone black and *L'Intransigeant* with plain, raw white? For the Japanese artist creates abstraction by reflex, and puts the flat tones side by side, with characteristic strokes capturing the movements or forms."

And in his next letter to Bernard:

"This is what I wanted to say about black and white. Take *The Sower*. The picture is divided in half; one half, the upper part, is yellow; the lower part is violet. Well, the white trousers rest the eye and distract it at the instant when an excessive simultaneous contrast of yellow and violet would irritate it."

"In another category of ideas, when you fashion a color motif conveying for example a yellow evening sky, the raw, harsh white of a white wall against the sky can if necessary be expressed, and in a curious way, by modulating the raw white with a neutral tone, for the sky itself colors it with a delicate lilac tone. Again, in this quite naïve landscape which is supposed to represent a hut entirely whitewashed (even the roof), standing on a decidedly orange ground, the southern sky and the blue Mediterranean induce an orange so much more intense that the whole scale of blues is raised in tonality. The black note of the door, windowpanes, and the little cross on top produces a simultaneous contrast of white and black as agreeable to the eye as that of blue with orange. ... Enough that black and white are also colors, for in many cases they can truly be regarded as colors, with their simultaneous contrast being as pungent as that of green and red, for example."

"What I wanted to find out is the effect of a more intense blue in the sky. Fromentin and Gérôme see the Midi region as colorless, and lots of people see it that way. Good heavens, yes, if you take a handful of dry sand, if you look at it closely, or water and air too, considered in this way, all are colorless.

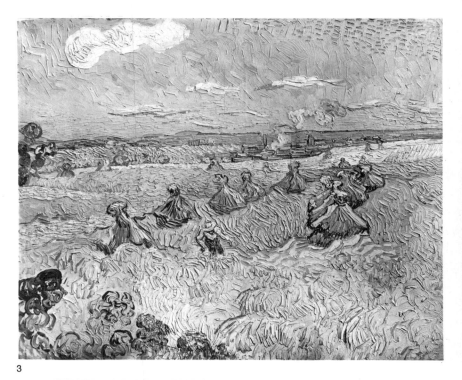

3

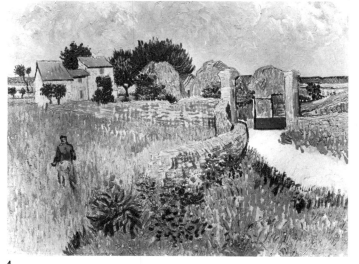

4

No blue without yellow and without orange, and if you use blue, then you use yellow and orange too, don't you?"

His descriptions of pictures he was working on, of landscapes, scenes, and people that had caught his eye, sometimes show an evocative command of words.

"There, at Saintes-Maries, there were girls who made you think of Cimabue and Giotto, slim, straight, a little sad and mystical. On the flat, sandy beach were small green, red, and blue boats, so pretty in shape and color that they reminded you of flowers."

"Often it seems to me that night is even more richly colored than day, colored with the most intense violets, blues, and greens. If you look carefully, you will see that certain stars are lemon-colored, others have pink, green, blue, or myosotis glints. ... And without laboring the point, in painting a starry sky it is obviously not enough to put white specks on blue-black. ... There you have a picture of night without black, with nothing but a fine blue and violet and green."

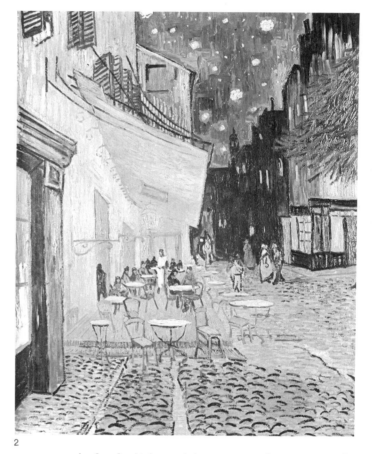

2

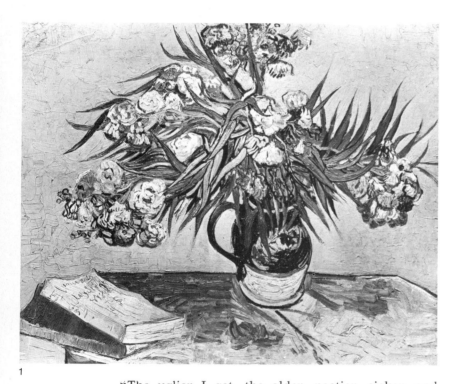

1

"The uglier I get, the older, nastier, sicker, and poorer, the more I want to avenge myself by going in for brilliant, well-contrived, resplendent color. ... And to manipulate the colors in a picture so that they vibrate and set each other off, something like putting together jewelry or designing costumes."

"Cornflowers with white chrysanthemums and a few marigolds, now there's a motif in blue and orange; heliotropes and yellow roses, a motif in lilac and yellow; poppies or red geraniums with solid green foliage, a motif in red and green—there's the groundwork, and it can be further subdivided, perfected and completed, but that's enough to make you see, without a painting, that there are colors which enhance each other, which blend, which complete each other as man and woman complete each other."

"The color here is truly very beautiful. When the

green is fresh, it is a rich green such as we rarely see in the North, a soothing green. When it is scorched and covered with dust, it does not become unsightly for all that, but the landscape then takes on golden tones of every shade: green-gold, yellow-gold, pink-gold, or bronzed or coppery gold, ranging

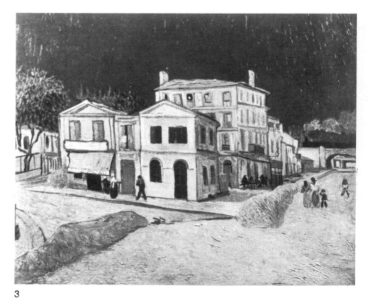

3

78

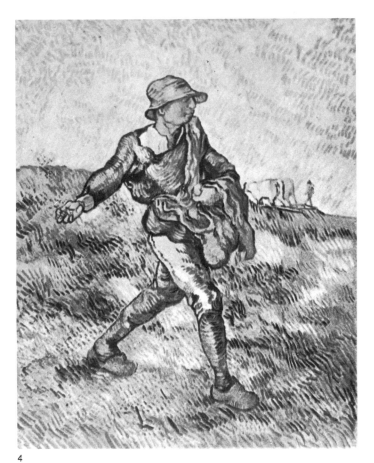

4

from lemon yellow to dull yellow—the yellow, for instance, of a heap of threshed grain. As for blue, it goes from the deepest royal blue of the water to the blue of myosotis, to cobalt blue, and especially to a transparent light blue, green-blue, and violet-blue. That naturally calls for orange; a sunburnt face provides orange. And then, since there is plenty of yellow, the violet at once begins to sing out."

Concerning his *Night Café*:

"In this canvas there are six or seven different reds, from blood red to tender pink, contrasting with as many pale or dark greens."

"Three nights running I stayed awake to paint, sleeping during the day. Throughout there is a contest and antithesis of the most differing greens and reds. I have tried to express with red and green those terrible things, human passions."

"The *Night Café* continues the *Sower*. ... It is not color that is locally true, from a realistic viewpoint of illusionism, but a color suggesting any emotion whatever of fervid temperament. ... What I have tried to express is that the café is a place where a man can ruin himself, go crazy, commit crimes. Finally, I have tried to express through [color] contrasts the power of darkness lurking in a low-class pothouse."

On the *Starry Night on the Rhone* and *Van Gogh's House at Arles*:

"Enclosed is a small sketch of a 30-square [cm] canvas, the starry sky painted the same night under a gas lamp. The sky is greenish blue, the water royal blue, the ground mauve. The town is blue and violet, the gas flame is yellow, and the reflections go from reddish gold down to greenish bronze. Against

the greenish blue of the sky, the Great Bear has a green and pink sparkle, whose discreet paleness contrasts with the brutal gold of the gas glow. Highly colored figures of two lovers in the foreground."

"Another sketch of a 30-square canvas representing the house and its surroundings under a sulfurous sun, in a sky of pure cobalt blue. The motif is a very hard one! But that's just why I want to carry it off. For it's terrific, these yellow houses in the sun, and then the incomparable freshness of the blue. All the ground is yellow too. I'll send you a better drawing of it than this sketch from memory; the house on the left is pink with green shutters, the one shaded by a tree."

Regarding *The Sower*:

"I'm working on a *Sower*: the huge field is all violet, the sky and sun very yellow. It's a very difficult subject to handle."

"The sky, a chrome yellow almost as bright as the sun itself, which is chrome yellow 1 with a bit of white, while the rest of the sky is chrome yellow 1 and 2 mixed. So it is very yellow."

"You feel from the very name of the tonalities that *color* plays a very important part in this composition. So the sketch as such worries me a great deal, inasmuch as I wonder whether it shouldn't be taken seriously and made into a terrific picture. My God, how I long to do it! But then I ask myself if I would be equal to the performance. ... So I am almost afraid of it. And yet, after Millet and Lhermitte, what remains to be done is ... the sower with color on a larger scale."

On his trip to Saintes-Maries-de-la-Mer:

"I write to you from Saintes-Maries, on the shores of the Mediterranean, at last. The Mediterranean is mackerel-colored, changeable that is; one doesn't always know whether it's green or violet, or if it's blue, for the next second the ever-changing reflection has taken a pink or gray tint."

"One night I walked beside the sea on the deserted beach. It was not gay, but not sad either—it was fine. The deep blue sky was streaked with clouds of a deeper blue than the primary blue of an intense cobalt, and others of lighter blue, like the bluish whiteness of the Milky Way. Against the blue background the stars shone brightly, greenish, yellow, white, and very pale pink, sparkling more like precious stones than they do at home, or even in Paris—and such they really seemed: opals, emeralds, lapis lazuli, rubies, sapphires."

About *Van Gogh's Bedroom*, in a letter to Gauguin (October 1888):

"To decorate my walls, I have also done a 30-square

1 Van Gogh's Bedroom. Arles, October 1888. Canvas, 28³/₈ × 35¹/₂ in. Amsterdam, National Museum Vincent van Gogh.

2 Portrait of the Shepherd Patience Escalier. Arles, August 1888. Canvas, 27¹/₈ × 22 in. England, Private collection.

3 "La Berceuse" (Portrait of Madame Augustine Roulin). Arles, January 1889. Canvas, 36¹/₄ × 28³/₄ in. Otterlo, Kröller-Müller Stichting.

4 The Plain of La Crau with Peach Trees in Blossom. Arles, April 1889. Canvas, 25³/₄ × 32¹/₈ in. London, Courtauld Institute Galleries.

canvas of my bedroom, with the softwood furniture you know about."

"Well, it was great fun doing this interior with nothing, as simple as a Seurat. In flat tints, but roughly brushed in, with a thick impasto, the walls pale lilac, the floor a broken and faded red, the chairs and bed chrome yellow, the pillows and sheets a very pale greenish yellow, the bedcover blood red, the washstand orange, the basin blue, the window green. With all these very different tones, you see, I wanted to express an absolute restfulness, and the only white is the slight note given in the black-framed mirror. ..."

And, concerning the same picture, in a letter to Theo:

"Color must here do the thing and, in giving through its simplification a greater style to things, be suggestive here of *rest* or sleep in general. Finally, gazing at the picture should rest the mind or, rather, the imagination. ... You see how simple the conception is. Shading and cast shadows are done away with; it is colored in flat and bold tones like Japanese prints."

Van Gogh often found it difficult to get models, either because he had no money to pay them or because people were reluctant to sit for a painter whose pictures seemed so utterly incomprehensible. But he needed this contact with live human figures, each one possessing some of the secrets he was so eager to find out.

"The people here [at Arles] are burned by the sun, their skin yellow and orange, and sometimes red ocher."

"I think there is something to do here in the way of portraiture. Although these people are miserably ignorant about painting in general, they are *far more artistic* than in the North, both in their person and in their way of life. I have seen figures here definitely as fine as any in Goya and Velázquez. They know how to stick a touch of pink into a black costume, or to put together an outfit of white, yellow, and pink—or even green and pink, or even *blue and yellow*—in which, from the artistic point of view, there is nothing to be changed. ..."

"I want to do figures, figures, and more figures. ..."

"Because of models I'm a bit worried for these last days of the week. ..."

"Trouble with models continues all the same, with the tenacity of the mistral here. This doesn't make me any more cheerful. ..."

"I feel that, even at this late hour, I could be a very different painter if I could solve the problem of models."

Elsewhere, Van Gogh speaks at length of the evocative power of color in conveying emotion:

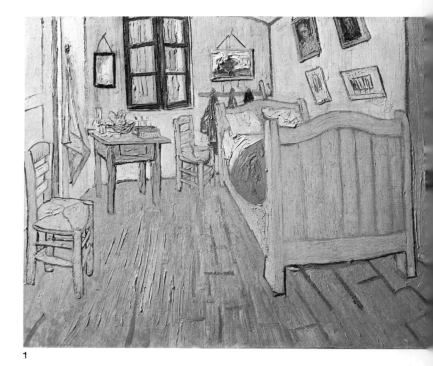

1

"I don't know if anyone before me has talked about suggestive color, but though Delacroix and Monticelli said nothing about it, they did it. ..."

"Ah, my dear brother, sometimes I know so well what I want ... in a picture ... to say something consoling like a musician ... to paint men and women with something eternal about them, which the nimbus once symbolized, and which we seek by means of the very radiance and the vibrancy of our color combinations. ..."

"To express the love of two lovers by a marriage of two complementaries, their blending and their contrasts, the mysterious vibrations of adjacent tones. To express a thoughtful brow by the radiance of a light tone on a dark ground. To express hope by some star. Or the ardor of a human being by the radiance of a sunset. This is certainly not eye-deceiving realism, but isn't it something that really exists?"

"I don't know if you will understand that one can utter poetry merely by arranging colors well, just as one can express consoling things in music."

Referring to his *Berceuse*, Van Gogh wrote to his friend the painter A. H. Koning:

"Have I sung a little lullaby with my colors?"

And to his brother Theo again:

"I have just talked to Gauguin about this picture— as he and I had been discussing Icelandic fishermen and their melancholy solitude, being exposed to

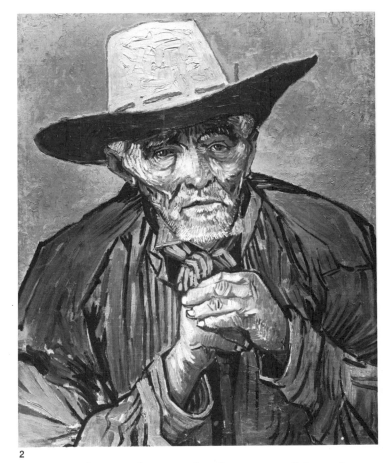

2

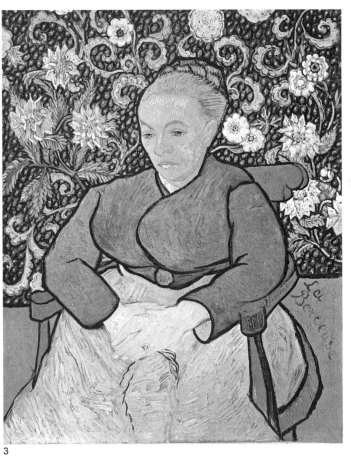

3

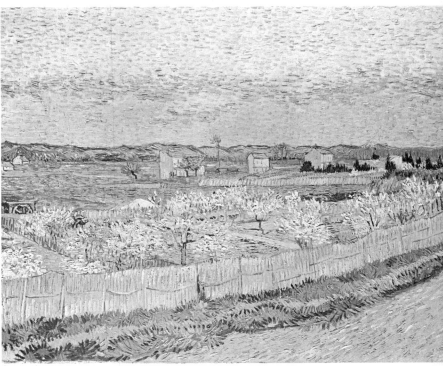

4

every danger, alone on the dreary sea—I have just been telling Gauguin that after these intimate conversations the idea came to me of painting such a picture that some sailors, who are at once children and martyrs, seeing it in the cabin of an Icelandic fishing boat, would feel a sense of rocking which reminded them of their nurse's lullabies."

Van Gogh discovered that he could render depth and distance *solely* by means of pure color, without resorting to forms or symbolic conventions.

"One must make a choice, and I hope to do so, and it will probably be for color."

To the law of complementaries he added the notion that color in itself has the power to convey space.

"While always working directly from the subject, I try to capture in the drawing what is essential— then the spaces, delimited by outlines, expressed or not, but felt in any case, I fill in with uniformly simplified tones, so that everything which is ground will share the same violet hue, and the whole sky will have a blue tonality, and the greenery will be either in blue-greens or yellow-greens, in this case purposely exaggerating the yellow or blue qualities."

When Van Gogh left Paris, he also left behind the debates and feuds of the artistic innovators and theorists. His own approach was empirical, and he applied no system. In following a single rule, that of his own taste, he created a world of signs. Without holding to a set technique, he variously followed the example of predecessors, notably Millet, Courbet, Delacroix, and Monticelli.

"I maintain that this artist [Monticelli] is entitled to a public, even though he has been appreciated too late. It is certain that Monticelli does not give us, and does not intend to give us, localized color— or even local truth. But he gives us something impassioned and timeless: a rich coloring, the wealth of sunlight of the glorious Midi, in the fashion of a true colorist, which can be compared with Dela-

croix's conception of the Midi; which is to say that the South of France is represented now by a simultaneous contrast of colors, of their derivatives and harmonies, and not by forms and lines having a value of their own, as was done in the past, by form alone as in the Greeks and Michelangelo or by line alone as with Raphael, Mantegna, and the Venetian primitives [sic]: Botticelli, Cimabue, Giotto, Bellini. ... The venture undertaken by Velázquez and Goya should be pursued and more fully—or rather, more universally, thanks to the more universal knowledge we have of prismatic colors and their properties."

Brushwork plays a key part in Van Gogh's art, and the paints can be applied in very different ways: now in

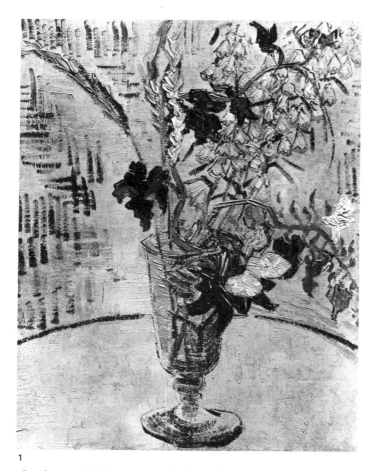

1

the form of plaques, as in Courbet, now in comma-like strokes, as in the Impressionists. He often drew with short strokes of the brush; this technique distinguishes him from others who used the brush to shade in a preliminary drawing of the form.

> "I realize that not one of the flowers is drawn in, that these are only strokes of color—red, yellow, orange, green, blue, violet; but the impression of all these colors, one after another, reappears in the picture as in nature."

In both his drawings and paintings he used the same hatchings, the same arabesques and dot patterns; but he used these devices sincerely and spontaneously, not as mere mannerisms or studio exercises.

> "But this confounded mistral is troublesome when it comes to laying on brushstrokes which hold together and which interweave with feeling, like music played with emotion."

The Impressionists banished storytelling and history from their canvases. No longer preoccupied with the problem of subject, they turned to painting the scenes of everyday life they saw around them. Contemporary critics considered these vulgar, both as subject matter and also for their manner of treating them. Cézanne's

opinion was that the artist must stand or fall on his own merits, not on those of his subject.

Van Gogh also worked directly from nature. When he spoke of being incapable of inventing his pictures, of working from imagination or memory, and when he dwelt on his need for models, he had already made a kind of transposition, for what he rendered as an artist was not the spectacle of nature he saw before him but as he felt it, expressing in poetic terms the emotion it aroused within him.

> "And I cannot work without a model. I do not say that I turn my back outright on nature to transform a study into a picture, by arranging the color, by magnifying and simplifying; but I am so afraid of straying from what is possible and right with regard to form. I do not speak of later, after ten years of study; but to tell the truth, I have so much curiosity about the possible and that which really exists that I have little desire or heart to look for the ideal as it might result from my abstract studies. ... But meanwhile I am constantly banqueting on nature. I exaggerate and sometimes change the motif; but in the end I do not invent the picture at all. On the contrary, I find it ready made, but I have to disentangle it from nature. ..."

> "I sometimes regret that I am unable to bring myself to work more at home and from imagination. To be sure, the imagination is a faculty we have to develop, and it alone can enable us to create a more exalting and comforting nature than we perceive of reality at a glance—for we see something changeable, gone in a flash."

The strong personality of Gauguin certainly influenced Van Gogh during their brief companionship in Arles, and thereafter he worked differently.

> "I'm going to try and work often from memory, for canvases done from memory are always less awkward and look more artistic than studies directly from nature, especially when one is working in mistral weather. ..."

> "My friend Paul Gauguin ... is now living with me. ... He has greatly encouraged me to work often from pure imagination."

> "Among these studies is the entrance to a quarry: rocks of a pale lilac on reddish ground, as in certain Japanese drawings. In the way of drawing and of dividing color into large planes, this is not unrelated to what you are doing at Pont-Aven."

But Van Gogh was always conscious of everything that separated him from the Impressionists and the Pont-Aven school. He had to chart a course of his own.

> "It is only that I find that what I learned in Paris *is leaving me*, and that I am returning to the ideas

1 Glass with Flowers. Auvers-sur-Oise, June 1890. Canvas, 16¹/₈ × 13³/₈ in. Private collection.

2 Hayricks. Arles, June 1888. Pen and India ink drawing, 9¹/₂ × 12¹/₂ in. Philadelphia Museum of Art, The Samuel S. White III and Vera White Collection.

3 Les Alyscamps. Arles, late October 1888. Canvas, 28³/₄ × 36¹/₄ in. Otterlo, Kröller-Müller Stichting.

4 The Belgian Painter Eugène Boch. Arles, September 1888. Canvas, 23⁵/₈ × 17³/₄ in. Paris, Musée du Louvre, Jeu de Paume.

which came to me in the country, before I knew the Impressionists. And I would not be surprised if before long the Impressionists were to find fault with my way of painting, which has been generated more by Delacroix's ideas than by theirs. ..."

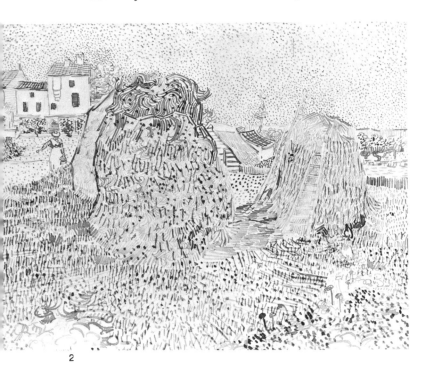

2

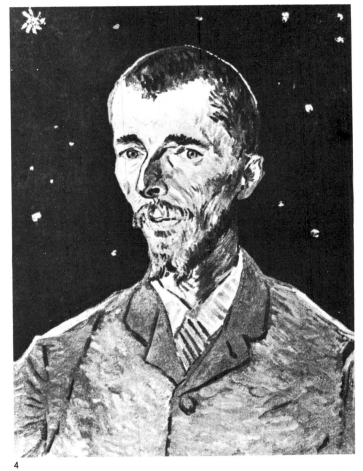

4

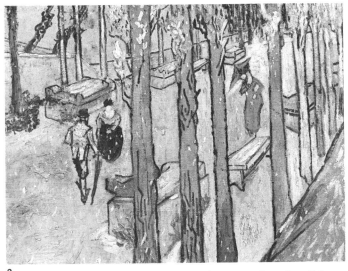

3

"For instead of trying to render exactly what I have before my eyes, I use color more arbitrarily to express myself strongly. ..."

"I should like to do the portrait of an artist friend, who dreams great dreams, who works as the nightingale sings, because his nature is such. He will be a fair-haired man. I should like to put into this picture the appreciation and the love I have for him. ..."

"So I'll paint him just as he is, as faithfully as I can, to begin with. But the picture is not finished in this manner. To finish it I am now going to be an arbitrary colorist. I exaggerate the fairness of the hair, I arrive at orange hues, chrome yellow, pale lemon."

"Behind the head, instead of painting the commonplace wall of the shabby apartment, I paint the infinite, I make a plain background of the richest, most intense blue I can concoct, and by this simple combination, the fair head gleaming against this rich blue ground, I obtain an effect as mysterious as the star in the deep-blue sky. ..."

"Only I begin more and more to search for a simple technique, which perhaps is not Impressionist."

"And I must tell you that just now I am striving to find a brushwork without dots or anything else, nothing but the varied brushstroke itself. ..."

"You see, all this is not in the least Impressionist; well, too bad! I do what I do surrendering to nature, without thinking of this or that."

Van Gogh distorted nature, distorted the motif, in order

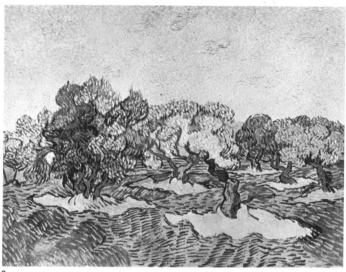

1

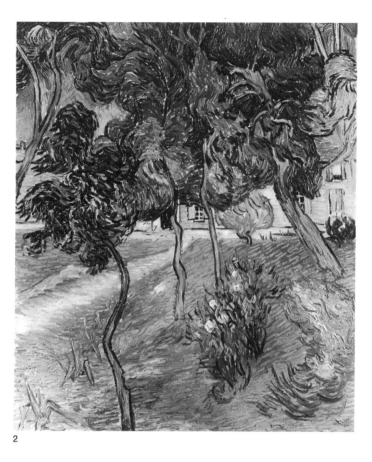

2

to bring out the innate structure. The brushstrokes and the sharp, vigorous hatchings, following a decided rhythm, give meaning to the color and the materialization of the image. This rhythm, truly Van Gogh's own life-rhythm, is rendered with a deft, swift execution.

"I have sometimes worked too fast. Is this a fault? I cannot help it."

"Thus I have painted a 30-square canvas, *Summer Evening*, at one sitting. Go back to work on it? Impossible. Destroy it? But why, since I went out in full mistral to paint it? Isn't it intensity of thought rather than calm brushwork we're after? And in the given circumstance of such impetuous work, done on the spot and directly from nature, is calm, well-regulated brushwork always possible? No more, it seems to me, than in a fencing match. ..."

"As for landscapes, I begin to feel that some, done even faster than usual, are the best I'm doing. While true that I am obliged to retouch *the whole thing* to adjust the composition a bit, to harmonize the brushwork, still at one sitting all the essential work has been done, and I spare it as much as possible in going back over it again. But when I return from a session like that, my brain is so tired. ... I see myself recovering from the mental effort of balancing the six essential colors: red, blue, yellow, orange, lilac, green. Work and sober calculation in which the mind is under great strain, like an actor onstage in a difficult role, where one must keep in mind a thousand things at once in the space of half an hour. ... But, do you know that I'm in the midst of a complicated calculation, resulting in canvases done at top speed one after another, yet calculated well *in advance*. And so, when they tell you it's been done too hastily, you can say that they have looked at them too hastily."

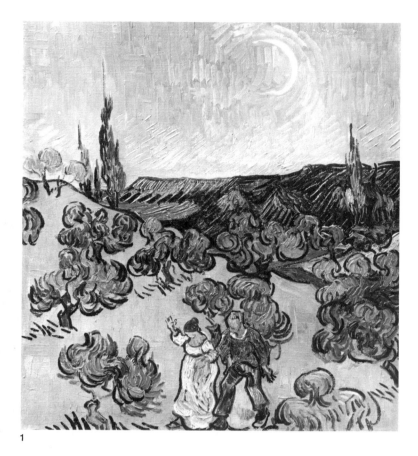

3

This transposed reality attained a dramatic, hallucinating pitch, the colors set up tensions within the picture, the visual signs became feverish and convulsive, the pigments took on an excited existence of their own, as if the artist was trying to express his own inner conflicts, his terrifying loneliness, the worries and privations so long endured, the sadness that no joy could ever again efface. His work became simpler and starker.

"What is always urgent is to lay out the lines, and whether it is done directly with the brush or something else, like the pen, one can never do enough. I am trying now to magnify the essential and leave the commonplace deliberately vague. ..."

"If I have asked for some watercolors, it is because I should like to do some pen drawings, but then colored with flat tints like Japanese prints."

"And I want to arrive at a more willful, more exaggerated line."

His brushwork became sinuous and undulating to render

the effect of volumes. Like an unending river, the pigments flow in all directions, delimiting and accentuating forms, spurting up in dizzy spirals. The rhythm pulsing through some of his pictures is like that of Van Gogh's own lifeblood.

> "Likewise, the curious lines, sought out and multiplied, winding throughout the picture are not there to present the garden in its everyday guise but to delineate it as if in a dream, at once in character and yet stranger than reality. ..."

> "Then I saw in this reaper—a vague figure struggling like a devil in unbearable heat to finish his task—then I saw the image of Death, in the sense that mankind itself might be the wheat being reaped."

Van Gogh never lost his lucidity of mind; his last letters are as clear and precise as any.

> "A huge trunk, but struck by lightning and sawn up. This gloomy giant—like some proud man brought low—contrasts ... with the pallid smile of a last rose. ... You will see that this combination of red ocher, of green saddened with gray, of black strokes fixing the outlines, produces something of the feeling of anguish which some of my fellow unfortunates often suffer from, and which is called 'red-black' [noir-rouge]. ... One can try to give an impression of anguish without aiming straight at the historic Garden of Gethsemane, just as to show a mild and consoling motif it is not necessary to represent the protagonists of the Sermon on the Mount. ..."

> "The *Olive Trees* ... like *Moonrise* and the nocturnal effect, these are distortions from the standpoint of arrangement, for their lines are contorted like those of old woodcuts. The olive trees are more in character, as in the other study, and I have tried to convey the time of day when the green beetles and the cicadas can be seen flying in the heat. ..."

> "There, where these lines are compressed and deliberate, the picture begins, even if that might be exaggerated."

Another passage in the same letter to his brother is full of good humor and testifies to his amazingly sound judgment:

> "It is a little like what Bernard and Gauguin feel. They do not care at all about the exact shape of a tree, but they do want you to say whether the basic shape is round or square — and of course they are right, being annoyed by the foolish photographic perfection of some. They do not care about the exact shade of some mountains, but they do say, 'Good God, were the mountains blue, then stick in blue and don't go telling me that it was a blue a bit like this or that. It was blue, wasn't it? Good—then make it blue and be done with it!'"

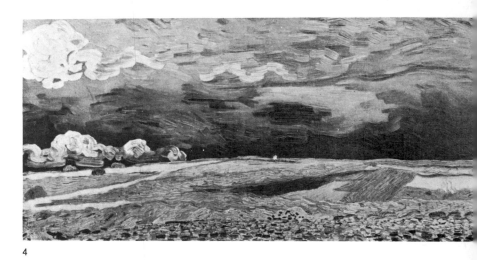

4

The nature he paints is animated with a mysterious, quivering force: his objects seem tremblingly alive within a profound silence, filled with a tense expectation of something else, that "true life" he so often dreamed of:

> "This brings up the eternal question: Is life visible to us in its entirety, or before death do we know but half of it?"

The letters written in the last weeks of his life suggest that he was conscious of being part of a vast community of living souls. To his sister Wilhelmien in June 1890, for instance, he wrote thus concerning modern portraits:

> "There is expression in our present-day faces, and passion, and something like expectation or like a cry. Sad but sweet, yet clear and intelligent. ..."

Then, to Theo in July 1890, the very month of his death:

> "I have since painted three more large canvases. These are immense stretches of wheat under overcast skies, and I have had no trouble in seeking to express sadness and extreme loneliness."

Van Gogh knew that, in the end, his painting would be understood and appreciated.

> "I don't know who it was who called this state 'being stricken with death and immortality.' The carriage that one drags along must be useful to somebody one doesn't even know. So there you are, if we believe in the new art, in the artists of the future, our premonition does not deceive us."

> "Do you know what I often think of, about what I used to tell you in the old days ... that even if I did not succeed, I still believed that what I had been working toward would be continued. Not directly, but one is not alone in believing in things that are true. And what does one matter personally, then!"

> "There is an art in the future, and it must be so beautiful and so fresh that, truly, if it costs us our youth now, we can only gain by it in serenity."

To that appeal and that hope the future has replied.

EXPERTISE

The problem raised by the existence of fake Van Goghs has been studied by several scholars, above all by Jacob Baart de La Faille, one of the foremost authorities on Van Gogh. In 1930 he published a catalogue of falsified Van Goghs, in which he identified two sources for most of them: sales held by the German dealer Otto Wacker, disposing of twenty-seven pictures apparently from the collection of a Russian emigré in Switzerland; and another series of pictures imitating the output of the painter's Paris period (these believed genuine by Théodore Duret), which for the most part had belonged to a collector named Proux from Asnières, near Paris. Baart de La Faille has also judged as fakes certain works in the style of both the early Dutch and the Arles/Saint-Rémy periods, as well as some drawings.

The Paris magazine *Connaissance des Arts*, in its October 1957 issue, published an expert's report in which M. van Dantzig listed the peculiarities that in his view characterize a genuine Van Gogh. These larger traits may be summed up as follows:

– His compositions are always taken from reality, from nature, and are never a combination of improbable subjects (i.e., motifs).
– He does not concern himself with minor details.
– His pictures give the impression of being larger than they really are.

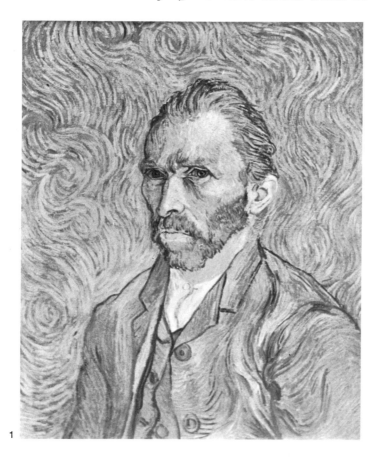

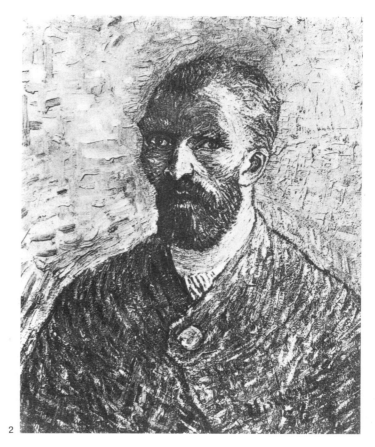

1 Self-Portrait. Saint-Rémy, May 1890. Canvas, $25^5/_8 \times 21^1/_4$ in. Paris, Musée du Louvre, Jeu de Paume.

2 Self-Portrait. 1888. Canvas, 24×20 in. [Fake.]

- Large masses are placed at the center of the picture.
- In general he indicates a great expanse of space, emphasizing the third dimension.
- Linear perspective is found in the lower part of the composition.
- The horizon line is usually located about three-quarters of the way up the canvas.
- Both extremes of light and dark tones are often found within the composition.
- Cold tones are usually dominant.
- He had a habit of finishing the picture by painting in the outlines.
- The parts that most attract attention are generally located toward the middle of the picture.
- The center is most fully worked out.
- The direction of brushstroke changes with the direction of the plane being rendered.

An interesting pamphlet entitled *Comment identifier Van Gogh* ("How to Identify Van Gogh"), published in 1967 by Marc Edo Tralbaut in relation to a work attributed to Van Gogh, gives a careful analysis of the different technical and aesthetic aspects of Van Gogh's paintings: the movement of his brushstrokes, the impasto, his concept of space and sky, the layout of planes, his imperative need to draw with the brush, and the importance of hatchings in his brush drawing.

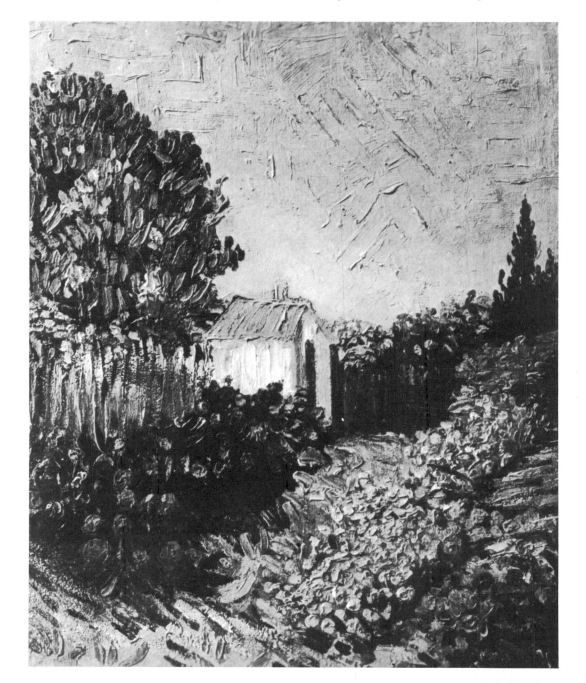

The Small Garden. Canvas,
17³/₄ × 14¹/₂ in. [Fake.]
Private collection.

VAN GOGH AND THE MASTERS

Owing to his family background and the profession for which he trained (along with his brother Theo), Van Gogh gained early familiarity with the art of the old masters. Before he ever became a painter he worked in daily contact with prints and reproductions; and he frequented the great museums of Holland and Belgium, and later Paris and London. He needed other artists—not to find himself, but to enrich and fulfill himself. His intuition, his artistic understanding was keen; he chose wisely, and the work of the masters he preferred opened windows on unknown worlds such as the Far East. For him, in art, the past was a living thing, like an immediate presence unobstructed by time or distance. "Japanese art is something like the primitives, like the Greeks, like our Dutch old masters ... there is no end to it."

In October 1885 he left Nuenen for a three-day visit to Amsterdam, where he spent his time in the Rijksmuseum, to refresh his memory of pictures he had not seen for a long time. Dazzled by *The Company of Civic Guards*, Van Gogh admired the way Hals heightened his colors by subtle contrasts of blacks and grays, the way it appeared he "laid on the color at one thrust." Rembrandt's *Jewish Bride* seemed to him painted "by a hand of fire." Later, after being given a copy of the Goncourts' book on eighteenth-century French art, he became a devotee of Chardin, whom he compared to Vermeer. He found a harbinger of Impressionism in Chardin's way of juxtaposing strokes of color on the canvas, so that at a distance they seemed to fuse into another color.

During his Nuenen period, intent on recording the daily life of the peasants, their physical traits related to their labor, Van Gogh invoked the example of Poussin, for whom "everything is at the same time reality and symbol." In his drawings of the same period, showing monumental figures of peasants at work, he surely had in mind the powerfully modeled figures of Michelangelo in the Sistine Chapel. He made mention also of the drawings of Daumier (*Soup*, for example, done in watercolor, charcoal, and pen), whose sinuous lines so strongly evoke volumes. He recalled Millet, for whom he felt genuine affection and whose themes he later took over and reinterpreted (*The Sower*). The idea

for *Shoes*, which he painted in several versions, came from a drawing by Millet that he saw in March 1882 in a monograph on the artist. Next, arriving in Paris, he discovered the work of Monticelli and was struck by the impasto of sumptuous color from which he built up his floral still lifes. While in the asylum at Saint-Rémy, lacking live models, Van Gogh made numerous copies in oil of pictures by other artists from prints or black-and-white drawings available to him. Of thirty-six such copies studied by Weisbach and Novotny, twenty-four were inspired by Millet works. These are not, of course, straightforward copies but "interpretations," for since they were made from monochrome reproductions or drawings, he improvised a color scheme of his own. Van Gogh himself described his copies as "recollections of their pictures—but a recollection and a vague consonance of colors which, if not the right ones, are those I feel. ... So then my brush goes between my fingers like a bow on a violin, and absolutely for my own pleasure." For Millet's pictures of rural life, he devised subdued and sensitive color harmonies. He felt that Millet's practice of doing sets of pictures (as Monet also was to do later), variations on such themes as the hours of the day or labors of the fields, furthered the public's understanding of his work.

Van Gogh's interpretations of Delacroix paintings were highly subjective. In his *Pietà*, Christ is shown with the red hair and square beard of the artist himself. When taking inspiration from a Rembrandt print, he identified with Lazarus and gave Martha and Mary the features of Madame Roulin and Madame Ginoux, the two women who had played a maternal, protective role in his life.

Van Gogh's attitude toward the masters was therefore very special and highly personal. He did not hesitate to borrow the themes of other artists who affected him strongly, reinterpreting them in his own terms and integrating their compositions into his own work. They provided the starting point or framework for some of his finest, most personal creations. They helped him to express his most secret thoughts. His elders, his artistic predecessors, were his brothers—a word that meant much to him.

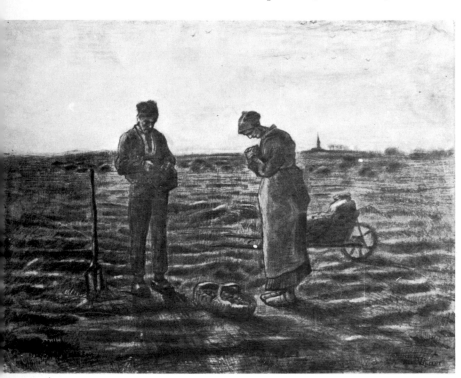

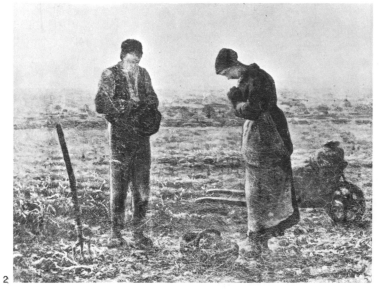

1 The Evening Angelus. Brussels, 1880. Drawing in pencil and red pastel with highlights in white lead, $18^{1}/_{2} \times 24^{1}/_{2}$ in. Otterlo, Kröller-Müller Stichting.

2 Jean-François Millet (1814–1875): The Angelus, 1859. Canvas, 21×26 in. Paris, Musée du Louvre. (Photo Giraudon)

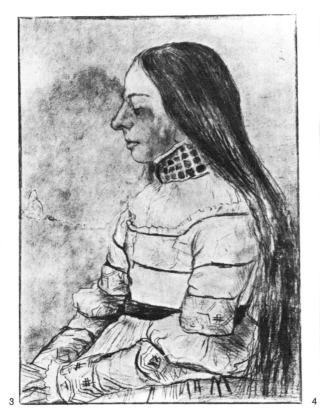

3

4

3 The Daughter of Jacob
 Meyer. Brussels, 1880.
 Charcoal and pencil,
 17 × 12 in. The Hague,
 Heirs of H. P. Bremmer.

4 Hans Holbein (1498–1543):
 Portrait of Anna Meyer,
 Daughter of Jacob Meyer
 zum Hasen. Before 1526.
 Colored chalks, 14 ×
 10³/₄ in. Basel,
 Kupferstichkabinett.

5 "Japonaiserie." Paris, summer 1887.
 Canvas, 41³/₈ × 24 in. Amsterdam,
 National Museum Vincent van Gogh.

 After a woodcut by Keisai (No. 6). The
 bamboo on the right was taken from an
 anonymous Japanese print (No. 7); the
 herons on the left from a detail in a
 print by Sato Torakiyo (1809–1889); the
 frog from a page of the "Mangwa" by
 Hokusai (1760–1849).

6 Cover of "Paris Illustré," May 1886.
 Paris, Bibliothèque Nationale. (Photo
 M. Lalance)

 On the cover of this issue of "Paris Il-
 lustré," devoted to Japan, is reproduced
 a woodblock print by Keisai (Eisen Ikeda,
 1790–1848) from the series of "Courtes-
 ans," originally measuring about 20 × 12 in.

7 Anonymous Japanese master: Bam-
 boo. Paris, Bibliothèque Nationale.
 (Photo M. Lalance)

 This Japanese print was published in
 "Paris Illustré" of May 1886, a special
 issue on Japan.

8 Père Tanguy. Paris, late 1887. Can-
 vas, 25⁵/₈ × 20¹/₈ in. Athens, Stavros
 S. Niarchos Collection.

 The Japanese figures in the background
 were taken from: Toyokuni III (Kunisada
 Utagawa, 1786–1864), left-hand figure;
 popular prints (flowers on the left); Ho-
 kusai, central part of the triptych "The
 Beauties of Edo" (upper right); Hiroshige,
 "View of Edo" from the series "Toto
 Meisho," c. 1850 (center right); Toyokuni
 III, "Actor in Female Role" (lower right).

7

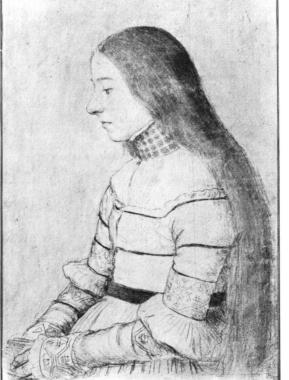

5

6

8

9 "Japonaiserie": Plum Tree in Blossom. Paris, first half of 1887. Canvas, $21^5/_8 \times 18^1/_8$ in. Amsterdam, National Museum Vincent van Gogh.

The Oriental calligraphy framing the picture is purely fanciful.

10 Hiroshige (1797–1858): Plum Tree in Blossom. Woodblock print from the series "One Hundred Views of Edo," 1856–1858, c. $14^1/_2 \times 10$ in. Paris, Musée Guimet.

11 "Japonaiserie": Bridge in the Rain, Paris, summer 1887. Canvas, $28^3/_4 \times 21^1/_4$ in. Amsterdam, National Museum Vincent van Gogh.

The Oriental calligraphy on the frame is purely fanciful.

13 Breton Women in a Meadow. Arles, 1888. Watercolor on paper, $18^7/_8 \times 26^3/_8$ in. Milan, Galleria d'Arte Moderna, Grassi Collection.

14 Émile Bernard (1868–1941): Breton Women in a Meadow, 1888. Canvas, $29^1/_8 \times 36^1/_4$ in. Saint-Germain-en-Laye, Private collection.

12 Hiroshige: The Ohashi in the Rain. Woodblock print from the "One Hundred Views of Edo," $14^1/_2 \times 10$ in. Paris, Musée Guimet.

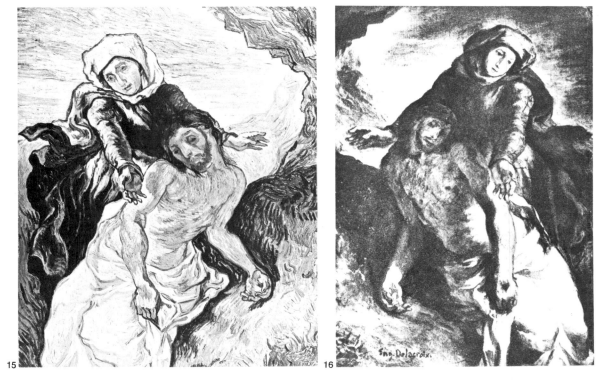

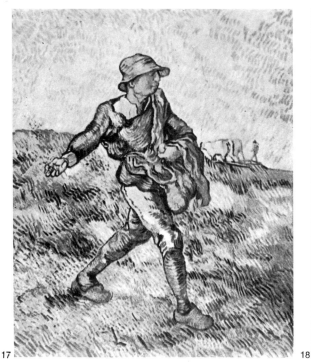

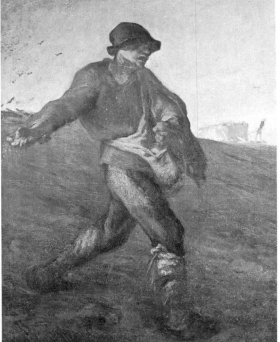

15 Pietà. Saint-Rémy,
 September 1889.
 Canvas, 28³/₄ × 23⁷/₈ in.
 After a lithograph (8⁵/₈ ×
 6¹/₂ in.) by Charles Nan-
 teuil from a canvas by
 Delacroix.

16 Eugène Delacroix
 (1798–1863): Pietà, 1850.
 Canvas, 13³/₄ × 10⁵/₈ in.
 Oslo, Nasjonalgalleriet.

17 The Sower. Saint-Rémy,
 January-February 1890.
 Canvas, 31¹/₂ × 25¹/₄ in.
 After an engraving (4³/₄ ×
 3³/₄ in.) by P. E. Lerat of
 Millet's "Sower."

18 Jean-François Millet:
 The Sower, 1850.
 Canvas, 39³/₄ × 32¹/₂ in.
 Boston, Courtesy of
 The Museum of Fine
 Arts, Shaw Collection.

19 Peasants Digging. Saint-Rémy, October-November 1889.
 Canvas, 28³/₈ × 36¹/₄ in. Amsterdam, National Museum
 Vincent van Gogh.

20 Jean-François Millet: Peasants Digging, c. 1860. Etching
 (fourth state), 9³/₈ × 13¹/₄ in.

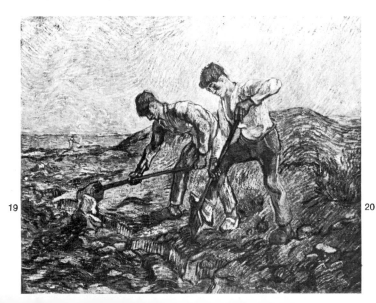

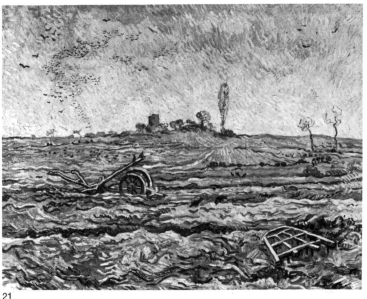

21 The Plain of Chailly. Saint-Rémy, January 1890. Canvas, 28³/₈ × 36¹/₄ in. Amsterdam, National Museum Vincent van Gogh.
After the engraving by A. Delauney of Millet's painting.

22 The Plain of Chailly by J.-F. Millet, in an engraving (4¹/₂ × 5¹/₄ in.) by A. Delauney found in Van Gogh's room. (Photo TELARCI)

23 Jean-François Millet: The Plain of Chailly, 1868. Canvas, 23⁵/₈ × 28³/₄ in. Vienna, Kunsthistorisches Museum.

22

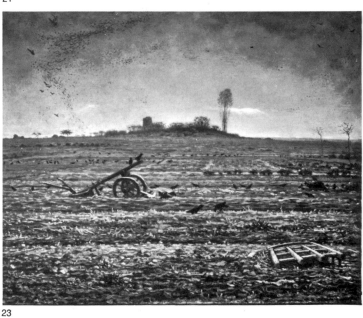

23

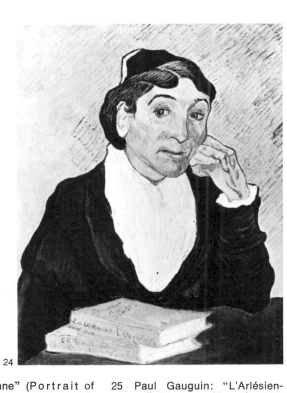

24

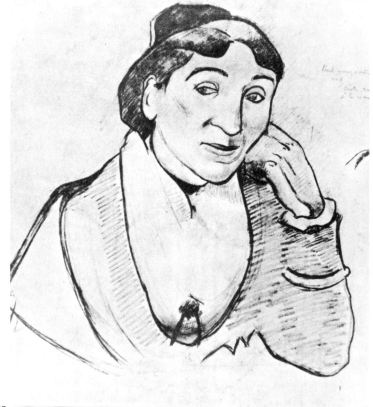

24 "L'Arlésienne" (Portrait of Madame Ginoux). Saint-Rémy, January-February 1890. Canvas, 25⁵/₈ × 19¹/₄ in. São Paulo, Museu de Arte.

25 Paul Gauguin: "L'Arlésienne" (Madame Ginoux), 1888. Charcoal drawing, 22 × 19 in. Bradford, Collection of Mr. and Mrs. T. E. Hanley.

25

26 The Prisoners'
Walk. Saint-Rémy,
February 1890.
Canvas, $31^{1}/_{2} \times$
$25^{1}/_{4}$ in. Moscow,
Pushkin Museum.
(Photo Lipnitzky-
Viollet)

After a wood engrav-
ing by H. Pisan of
Gustave Doré's drawing
"Newgate, Exer-
cise Yard" (No. 27).

27 Gustave Doré
(1833–1883):
Newgate, The
Exercise Yard.

Wood engraving by
H. Pisan after a
drawing by Gustave
Doré, as published
in the volume "Lon-
don, a Pilgrimage"
by Gustave Doré and
Blanchard Jerrold,
London, 1872.

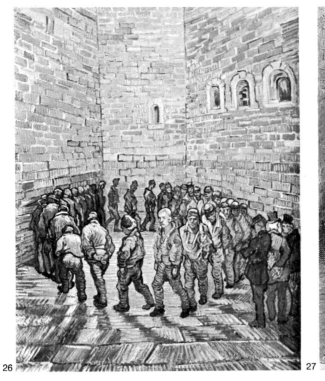

26

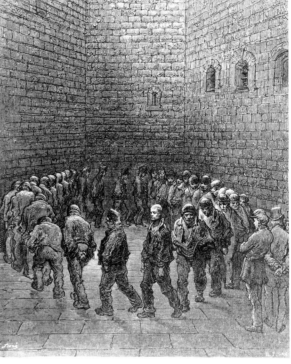

27

28 Woodcutter. Saint-
Rémy, February
1890. Canvas,
$17^{1}/_{8} \times 9^{7}/_{8}$ in.
Amsterdam,
National Museum
Vincent van Gogh.

29 Wood engraving
by J. A. Lavieille
of J.-F. Millet's
"The Woodcutter."
$7^{1}/_{4} \times 4^{3}/_{4}$ in.
(Photo TELARCI)

30 Jean-François
Millet: The
Woodcutter
c. 1855. Canvas,
$15 \times 11^{5}/_{8}$ in.
Paris, Musée du
Louvre. (Photo
Musées Nationaux)

28

29

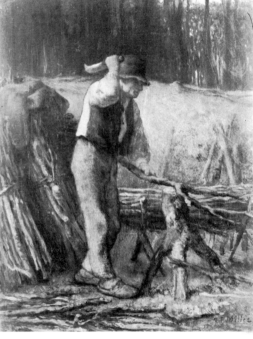

30

31 The Raising of
Lazarus. Saint-
Rémy, May 1890.
Canvas, $19^{1}/_{8} \times$
$24^{3}/_{4}$ in. Amsterdam,
National Museum
Vincent van Gogh.

32 Rembrandt (1606–
1669): The Large
Raising of Lazarus,
1631–1632. Etching,
$14^{1}/_{2} \times 10^{1}/_{3}$ in.
Amsterdam,
Stedelijk Museum.

31

32

BOOKS ABOUT VAN GOGH

Innumerable books have been written about Van Gogh in many languages. Since it is impossible to list them all, this bibliography is limited to several standard works and some of the more interesting, better-informed studies.

Catalogues:

The standard work is the new edition of Jacob Baart de La Faille's *catalogue raisonné*, first published in Brussels in 1928 in four volumes (Les Editions Van Oest), reissued in Paris in 1939 (Hyperion), and more recently revised and updated in one volume: *Works of Vincent Van Gogh: Paintings and Drawings*, Meulenhoff International, Amsterdam-London-New York, 1970. In 1930 Baart de La Faille also published a useful catalogue of fake Van Goghs (Brussels, Les Editions Van Oest).

Letters:

The best and most complete edition of the Van Gogh letters, superseding previous collections, is that published under the editorship of Theo's son Vincent W. van Gogh, the artist's nephew and godson: *Versamelde Brieven van Vincent van Gogh*, Wereld-Bibliotek, Amsterdam, 1952–1954, 4 vols.; reissued in 2 vols., 1955. From this edition, in which all the letters are published in their original language (Dutch, French, and a few in English), was made the standard English edition: *The Complete Letters of Vincent van Gogh*, New York-London, 1958, 3 vols. Another noteworthy edition, in French, was published with a preface and notes by Georges Charensol: *Correspondance complète de Vincent van Gogh enrichie de tous les dessins originaux*, Gallimard-Grasset, Paris, 1960, 3 vols.

Monographs and Biographies:

One of the outstanding Van Gogh books of recent years, well illustrated and richly documented, is Marc Edo Tralbaut, *Vincent van Gogh*, New York-London-Lausanne, 1969. From among many historians of modern art who have published studies of Van Gogh, we cite the following works: A. Artaud, *Van Gogh, le suicidé de la société*, Ed. K., Paris, 1947; H.P. Bremmer, *Vincent van Gogh, Inleidende Beschouwingen*, W. Versluys, Amsterdam, 1911; G. Coquiot, *Vincent van Gogh*, Ollendorff, Paris, 1923; P. Cabanne, *Van Gogh, l'homme et son œuvre*, Editions Aimery Somogy, Paris, 1961; R. Cogniat, *Van Gogh*, Editions Aimery Somogy, Paris, 1959; T. Duret, *Van Gogh*, Bernheim Jeune, Paris, 1916; P. Courthion, *Van Gogh raconté par lui-même et par ses amis, ses contemporains, sa postérité*, Pierre Cailler, Geneva, 1947; A. M. Hammacher, *Vincent van Gogh*, Becht, Amsterdam, 1948; L. Hautecœur, *Van Gogh*, Documents d'Art, Munich, 1946; R. Huyghe, *Van Gogh*, Flammarion, Paris, 1958; G. Knuttel, *Van Gogh der Holländer*, XIIIᵉ Congrès International d'Histoire de l'Art, A. B. Hasse U. Tullbergs Boktryckeri, Stockholm, 1933, pp. 193-195; J. Leymarie, *Van Gogh*, Pierre Tisné, Paris, 1951; *Qui était Van Gogh?*, Geneva, 1968; J.A. Meier-Graefe, *Vincent van Gogh der Zeichner*, Otto Wacker, Berlin, 1928; L. Pierard, *La vie tragique de Vincent van Gogh*, Crès, Paris, 1924 (2d ed. Correa, Paris, 1939); J. Rewald, *Post-Impressionism: From Van Gogh to Gauguin*, The Museum of Modern Art, New York, 1956; M. Schapiro, *Vincent van Gogh*, "The Library of Great Painters", Harry N. Abrams, New York, 1950; C. Terrasse, *Van Gogh peintre*, "Anciens et Modernes", Floury, Paris, 1953; M. Valsecchi, *Van Gogh*, Milan, 1957; W. Pach, *Vincent van Gogh: A Study of the Artist and His Work in Relation to His Time*, Artbook Museum, New York, 1936; H. Perruchot, *La vie de Van Gogh*, Hachette, Paris, 1955.

Psychological Studies:

A number of writers have studied the problems raised by Van Gogh's psychological make-up and mental troubles; we cite, in particular, the following studies in this area: Joachim Beer (1936), V. Doiteau and E. Leroy (1928), H. R. Graetz (1963), Karl Jaspers (1922), C. Mauron (1953), J. A. M. Meerloo (1931), Françoise Minkowska (1963), H. Nagera (1967; foreword by Anna Freud), and "Vincent van Gogh's Quest for Identity," *Netherlands Yearbook for History of Art* (1963).

Museums with at least 3 works by Van Gogh

EUROPE

DENMARK
COPENHAGEN – Ny Carlsberg Glyptotek

FRANCE
PARIS – Musée du Louvre (Jeu de Paume); Musée Rodin

GERMANY
ESSEN – Folkwang Museum
MUNICH – Bayerische Staatsgemäldesammlungen
WUPPERTAL – Museum von der Heydt

GREAT BRITAIN
EDINBURGH – National Gallery of Scotland
LONDON – National Gallery; Tate Gallery

NETHERLANDS
AMSTERDAM – National Museum Vincent van Gogh; Stedelijk Museum
OTTERLO – Rijksmuseum Kröller-Müller Stichting
ROTTERDAM – Museum Boymans-van Beuningen
THE HAGUE – Gemeentemuseum

SWITZERLAND
BASEL – Kunstmuseum
WINTERTHUR – Oskar Reinhart Collection am Römerholz
ZURICH – Kunsthaus

U.S.S.R.
MOSCOW – Pushkin Museum

● **MUSEUMS WITH AT LEAST 3 WORKS BY VAN GOGH**

● **MUSEUMS WITH LESS THAN 3 WORKS BY VAN GOGH**

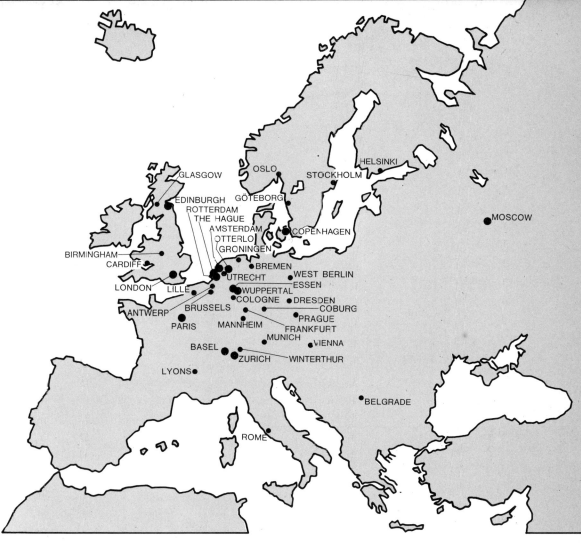

VAN GOGH IN MUSEUMS

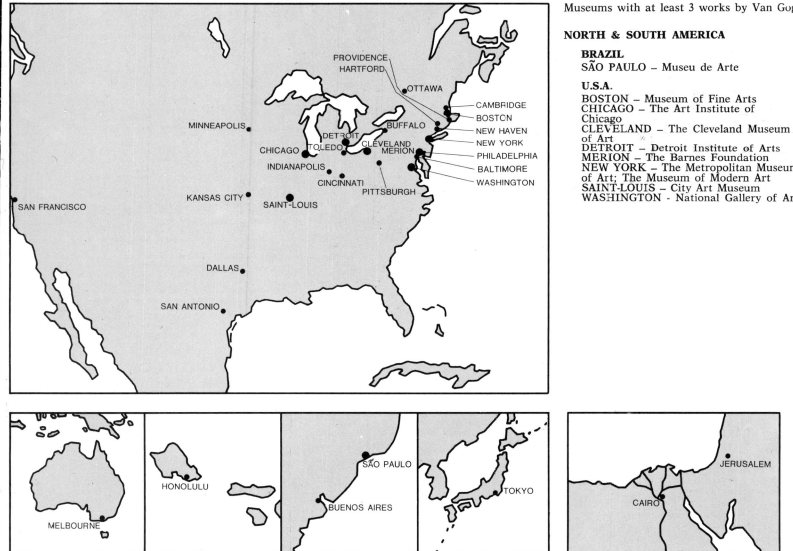

Museums with at least 3 works by Van Gogh

NORTH & SOUTH AMERICA

BRAZIL
SÃO PAULO – Museu de Arte

U.S.A.
BOSTON – Museum of Fine Arts
CHICAGO – The Art Institute of Chicago
CLEVELAND – The Cleveland Museum of Art
DETROIT – Detroit Institute of Arts
MERION – The Barnes Foundation
NEW YORK – The Metropolitan Museum of Art; The Museum of Modern Art
SAINT-LOUIS – City Art Museum
WASHINGTON - National Gallery of Art